Marking the Land

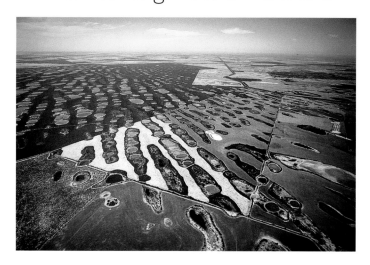

Marking the Land

a collection of Australian Bush Wisdom & Humour

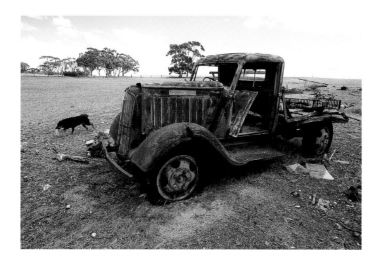

edited by Brian Dibble and Jim Evans
with photographs by Richard Woldendorp

University of Western Australia Press

First published in 2005 by
University of Western Australia Press
Crawley, Western Australia 6009
www.uwapress.uwa.edu.au

Introduction and compilation © Brian Dibble and Jim Evans, photographs © Richard Woldendorp: prose and poetry rights retained by individual copyright holders (see pp, 85–93) 2005.

Every effort has been made to seek copyright permission. Copyright holders not acknowledged should contact the publisher. For permissions, we thank Macquarie Publishing for items from the *Macquarie Dictionary*, Penguin, the Tasmanian Adult Board of Education and Viking.

National Library of Australia
Cataloguing-in-Publication entry:

Marking the land: a collection of Australian bush wisdom and humour.

 Bibliography.
 ISBN 1 920694 46 3.

 1. Australian wit and humor. 2. Aphorisms and apothegms.
 3. Humorous poetry, Australian. 4. Australia—Humor. 5. Australia—Pictorial works.
 I. Evans, Jim. II. Dibble, Brian. III. Woldendorp, Richard, 1927–.

808.8700994

Half-title photograph: Marginal farming among the salt lakes
Title-page photograph: Derelict truck on a farm near Corrigin, Western Australia

Consultant editor: Jean Dunn Melbourne
Designed and typeset by Sandra Nobes, Tou-Can Design
Pre-Press by Hell Colour Australia
Printed by Everbest Printing Co., China

to those country people

who are doing it tough

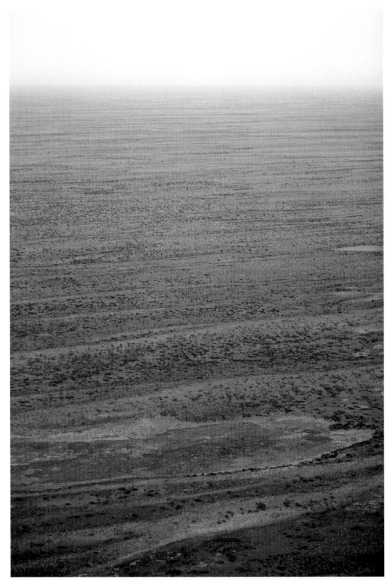

Strezlecki Desert, South Australia

Introduction

We share an interest in the people, spirit and dimensions of the Australian bush, and the insights and images you will find here reflect thousands of expressions collected and photographs taken during the past two decades. The sayings come from a wide variety of sources—from newspapers and advertisements, from popular and professional journals, from essays, songs, poems, plays, short stories and novels, from popular and academic books on Australian humour, from dictionaries, colleagues, friends and acquaintances, and from our own experience. We disregarded most jokes, as well as slang and idiomatic items mainly of linguistic interest, because they are widely collected in other books. Rather than separate the wisdom from the humour, we have mixed the sayings to complement Richard Woldendorp's photographs.

Our sayings come from the settlers and their descendents who marked the land and were marked by it, for better or worse. Some are British in origin but have acquired somewhat different meanings in the process of naturalisation. The seventeenth-century observation that it is as well to be hanged for a sheep as a lamb has special resonances in a country where sheep outnumber people by five to one and where the unofficial national anthem celebrates a swagman stealing a jumbuck.

Many of the humorous insights reflect how the convict colony developed over two hundred years. They indicate an ironic Australian attitude toward life and an initial perception of the land in negative terms. Thus bush humour attempts to compensate for

the vastness, harshness and inhospitableness of the land by giving perspective and by proposing alternative understandings: the grass isn't greener anywhere else, and at least half of your problems are of your own devising; you can cry, or you can laugh. In coming to terms with the inevitable, bush humour says 'You might as well laugh'. Henry Lawson was recommending just such a response in his poem 'Keep your smile in working order', in anticipation of that time 'when your pants begin to go'. Such a prescription uses humour as an antidote to self-importance, as a relaxant, and as a tonic that encourages fellow feeling.

We have chosen sayings that are humorous in idea and in expression, and are Australian in some significant way. Of course, to call something humorous is an indirect way of defining oneself: we are saying that these attract us, please us, make us smile or laugh on the inside as well as the outside. We hope they will do so for others also, perhaps serving like an elixir to bring the spiritual humours into a happy balance.

We chose the wisdom sayings for a variety of reasons. With some we were struck by the ways in which they were ironic, sardonic or just plain odd. Others we found edifying—that is, instructive or enlightening for their thoughts about life and how to deal with it. Concern with nature, with society and with interpersonal relationships, and themes about adversity, about good spirit, about endurance and so on, prevail in all cultures. But we are struck by their unique expression in rural Australia. Sometimes that uniqueness inheres in the Australian idiom, but as often it resides in the Australian habit of mind.

There is factual information in the wisdom about such things as the qualities prized in a working dog. There is also bush craft or farm lore whose canniness particularly intrigues us, like the mnemonic illustrating the belief that the more white on a horse below the knee (especially if it has a white nose too), the less fit it will be for racing. It is a belief shared by breeders of Arabian horses, and one that can be counted on to start an Australian vet off on a vigorous endorsement or a rigorous disproof:

Four white feet, send him right away.
Three white feet, keep him not a day.
Two white feet, sell him to a friend.
One white foot, keep him till the end.

Then there is personal advice, which commends contemplation, hospitality, frugality and reticence—every man 'should spend an hour a day looking into a fire' and should know that 'There's no exception to the rule of bush hospitality'; he would do well to 'Keep short arms and long pockets' and 'Never probe into a man's past' or, comparably, 'Never touch another man's dog'. And some of the more memorable sayings are proverbs or aphorisms that imply worldly advice, like 'A rooster today, a feather-duster tomorrow' and 'The wider the brim, the smaller the property'.

Mateship is a recurring theme, and some of the sayings emphasise the Anglo-Saxon Protestant values that gave rise to that particular sort of bonding between Australian men. Some sketch an Australian theology, which might best be described as whimsically sceptical: 'Maybe there's a God who knows' is about as categorical an Australian proof for a Creator that can be found. Comparably, Australian bush eschatology is at its most specific in the supposition that 'The chances are I go where most men go'. And generally the philosophy operates within a very narrow range—'You've got two chances, Buckley's and Nunn'—or with the fatalistic if euphemistic certainty that fate is 'waiting to do the decent thing' or, more brutally, that 'You are bound to be crow's meat'.

The bush is a deep source of imagery for Australian culture. Long before Crocodile Dundee, the idea of Australia conjured up images of koalas and kangaroos for people overseas. And within Australia too, the city-shunning man who is self-reliant and without affectation, who is laconic and sceptical, but hospitable too, and capable of blind devotion to a male mate—the character described by Russel Ward in *The Australian Legend* (1958)—is a

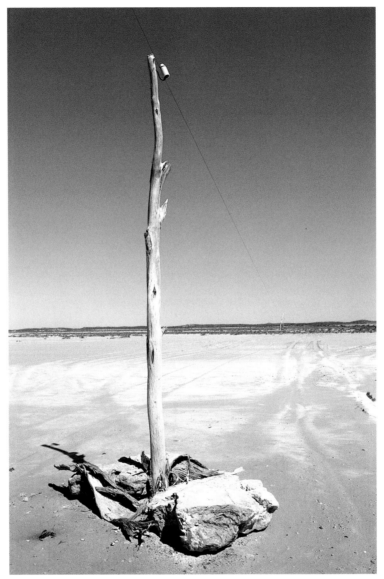

Telegraph pole on the Nullarbor Plain, Western Australia

powerful icon, despite the fact that Australia is one of the most urbanised countries in the world. At work here are the complementary beliefs that the good old days were better days, and that the simpler life is the better life, both impulses pointing to the bush. Whether or not those intuitions are true is not so relevant as the fact that the sayings they inform give us insight into our own lives, and advice on how to deal with life.

We two wear different hats at different times—mortar boards, Stetsons or Akubras—for we are professors/farm-owners: Jim Evans (Agricultural Communications at the University of Illinois) grows corn and soybeans on his 120 acres at Winfield, Iowa, and Brian Dibble (Comparative Literature at Curtin University) runs beef cattle on 320 acres at The Lakes, Western Australia. Teaching and farming are uniquely compatible activities for, as anyone familiar with bush or cowboy lore would know, farming is rivalled only by gambling as the quickest and most reliable way to disperse money acquired elsewhere. We are thus well placed in that regard, and so we constantly benefit from recourse to bush humour, if not wisdom.

Many thanks are due: especially to research assistants Win-Yuan Shih at the University of Illinois and Kaye Palmateer and Lynnette Keenan at Curtin University of Technology; to Curtin University for awarding a Haydn Williams Fellowship to Jim Evans in the 1990s and a sabbatical to Brian Dibble, resulting (in part) in this collection; and to Paul Myers, then of the Rural Press Group, who supported our efforts to establish Australia's first course in Rural Journalism. Paul Myers also arranged for the Rural Press to sponsor a bush wisdom contest that Jim Evans judged. Entrants to that contest provided a number of the items that appear here, reassuring us about our intuition that a unique bush ethos still obtains in Australia. Thanks also to our colleague Sue Grey-Smith for the idea of combining the sayings with Richard Woldendorp's photographs and for much other invaluable help.

BRIAN DIBBLE AND JIM EVANS

You can't beat the dawn, an' the first faint breeze. It's like a cool, soft hand on your face.

The Great Outback: a place where the drover is driven and the shearer is shorn.

If it moves, shoot it. If it stands still, chop it down.

What's a few inches or so in a big country like this?

Fleas, flies, bugs and sand—
All belong to Groper land.

Sydney or the bush.

'Out back' is always west of the bushman, no matter how far out he be.

Like a kiss on the mouth
The waratah blows.

The bush is always callin'.

It's the bigness that makes you lonely.

Me mate, me dogs an' horses an' me, we kinda, by God, like to be alone.

Marking the land

*The bush holds its secrets; hides them
fast in its great, desolate quietness.*

*To lose the points of the compass is to
lose your life.*

Call me when the Cross turns over.

*The great Bush sings to us, out and back,
And we lie in her arms and listen.*

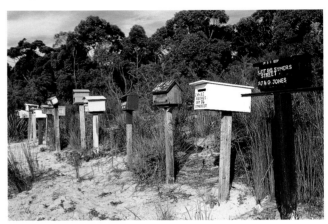

Roadside letterboxes

*Every living thing hunts every living
thing in the plain.*

You need good eyes in the bush.

With good bush eyes, we might see.

*You'll mostly find that these far-out-back-of-beyond places have got men and women to
match 'em.*

Bulwaddy when very old will break and burn, but it never bends.

Farmin's a science and a gamble.

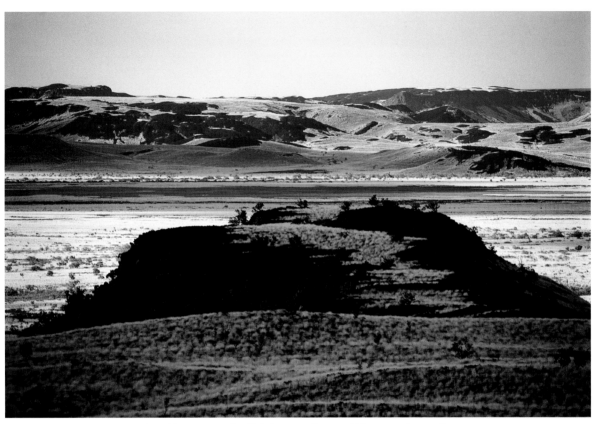

Looking towards Chichester Range, Western Australia

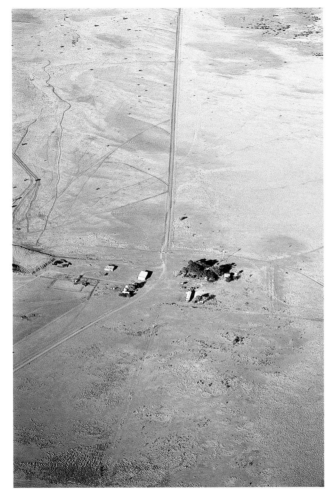

Station homestead, west of Mount Isa, Queensland

There's no Sunday in the bush.

Cockies' hours are from jackass to jackass.

The only way to acquire a farm is to inherit one or to marry one.

The best and quickest way to acquire a fortune is to bring it with you.

I cannot keep the land any longer because the land will not keep me.

Grab life by the shirt front and shake it before it does the same to you!

You have two chances, Buckley's and Nunn.

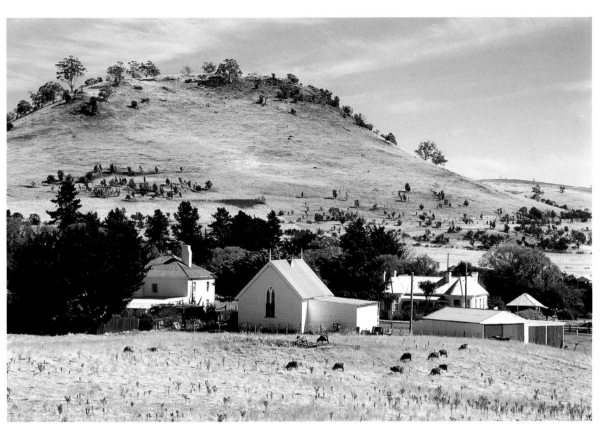

Sheep farm in central Tasmania

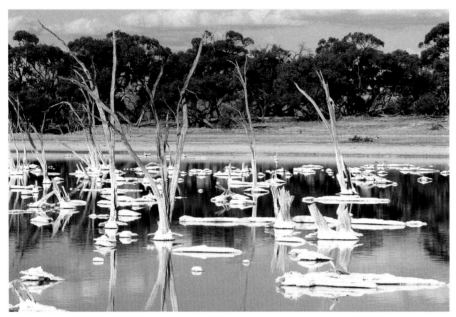

Salt-encrusted remains of a forest

I'm too soft for this country and not tough enough for any other,
so it's no good me shifting.

This country's kind if you know how to use her.

She holds my present, future, memory.
What can I love, if not the bare brown land?

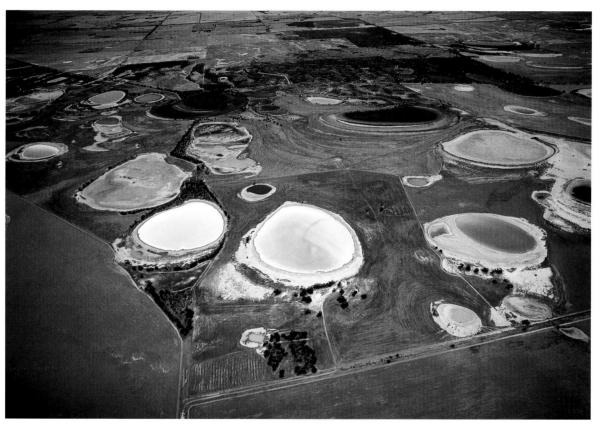

Salt lakes affected by agricultural run-off, Lake Grace, Western Australia

Up here, you see hope every day.

Any cocky not having a tough time in a tough time is most likely married to a teacher or a nurse.

There's plenty of hard work in the bush but nuthin' at the end of it.

A shut mouth catches no flies.

Heat, flies, hard tucker, an' on yer flamin' own from mornin' till dark.

From bootstraps to bootstraps in three generations.

Pretty well everybody occasionally gets more than he wants, but rarely does anyone get as much as he wants.

It often takes a strong man to be a fool.

You can't sit on a fence forever.

The rain is sure to find you in the old bark hut.

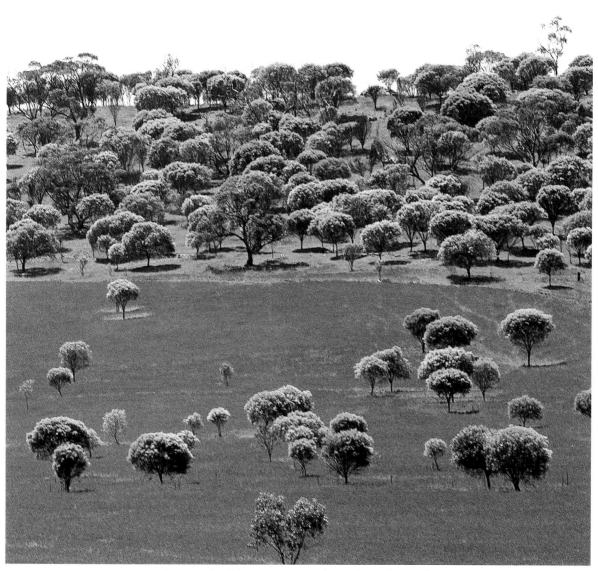

Paterson's Curse, common throughout Australia

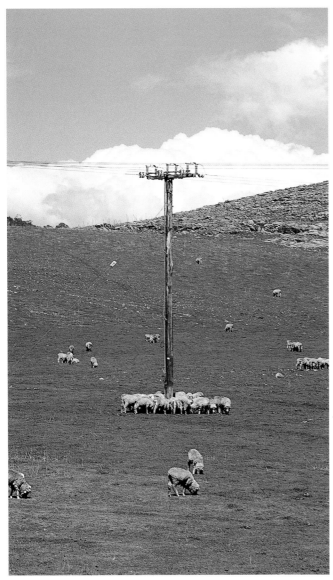

Sheep around a power pole, South Australia

The farmer's trade is one of worth,
It's partners with the sky and earth,
He's partner with the sun and rain,
And no man loses from his gain;
And men may rise and men may fall:
But the farmer he must feed them all.

Had chats been sheep, many of us
would be squatters.

No wood. No tucker.

Less talk and more work.

If you ever go to work, no matter
what your wages are, or how you are
treated, you can take it for granted
that you're sweated.

Just keep away from 'headin' 'em',
 and keep away from pubs,
And keep away from handicaps—for
 so your sugar scoots—
And you may own a station yet and
 wear the Boss's boots.

Rustling is only droving, with an
extra note of gambling and suspense.

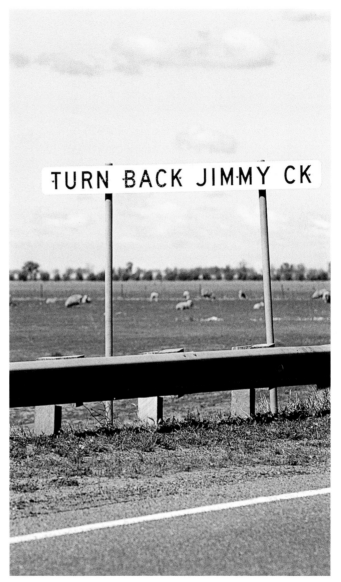

Turn Back Jimmy Creek, New South Wales

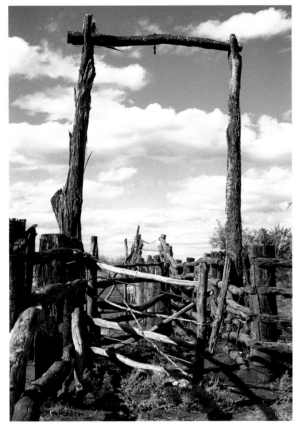

Timber mustering yards at Murchison,
Western Australia

*He's punished less who roundly robs the
 nation*
*Than he who nabs a jumbuck from a
 station.*

*A good shepherd is without price, but a bad
one is worse than none at all.*

Australia rides on the sheep's back.

If the sheep get boxed, you must yard them.

*One young breeding ewe is worth three old
gummies.*

*A sheep shorn may live to be shorn again,
but a sheep boiled is gone forever.*

Out of all this wild confusion,
After Meditation deep,
I have come to this conclusion
That the road to hell is sheep.

Fancy workers, fluke and fluster,
Footrot, blowflies, crows and kites,
Mongrels, maggots, mutton, musters,
Fill the days and haunt the nights...

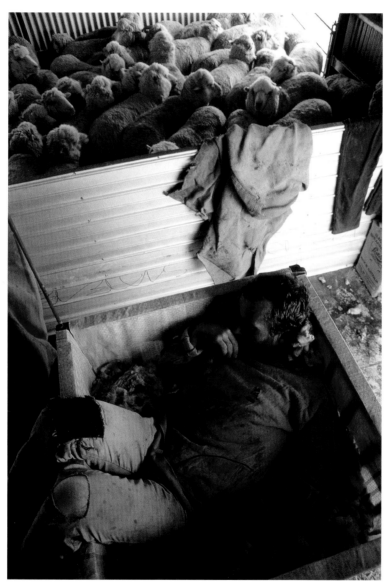

After a hard day's work

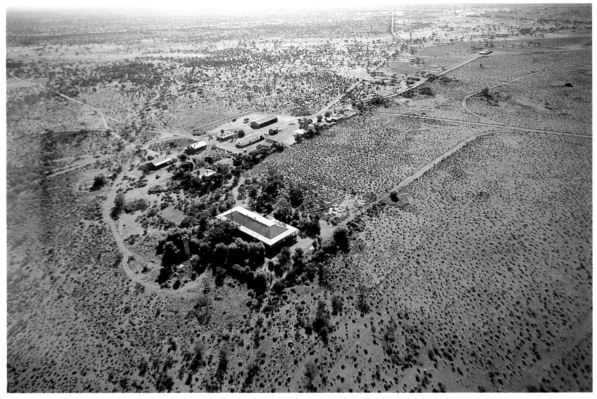

Station homestead, South Australia

God bless the Boss and all his rich relations,
And don't let the bagmen camp around the stations.

Squatterdom wears gloves because its hands are not clean.

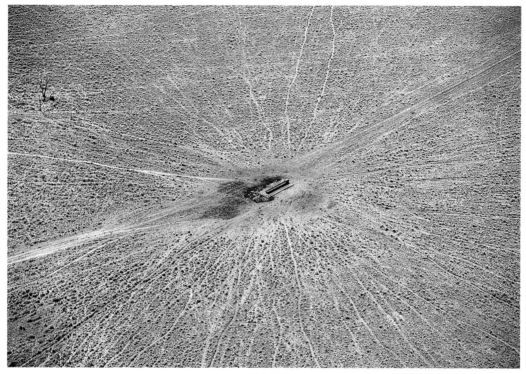

Waterhole on the Barclay Tablelands, Northern Territory

Can I help it, boss, if I'm a slow sleeper?

The Cardinal Rule for jackaroos:
Don't report a problem, but only what you have done about it.

Dogs may bark and men may shriek, but the sheep won't move.

For every drover who sat around a campfire cracking jokes with the boys there was a drover's wife doing the same with the girls in the wattle-and-daub kitchen.

Always camp at the first water after dinner.

Start them early, keep them straight, Feed them well, camp them late.

Don't camp a herd in the open, or you'll find yourself without.

The mob are on their toes—you must ride wide.

It's a fine day for travellin'.

Laughing-sides wouldn't last long in a boggy cowyard.

If it's a pet you want, get yourself some fancy dog and pet it. But if you're droving sheep, you get a kelpie and treat it like a good drover's dog.

Why keep a dog and bark yourself?

It must make the angels weep To hear a mob of shearers in a bar room shearing sheep.

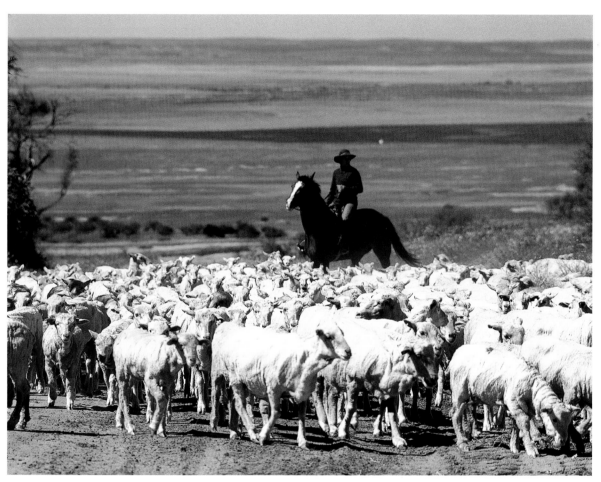

Droving sheep near Mullewa, Western Australia

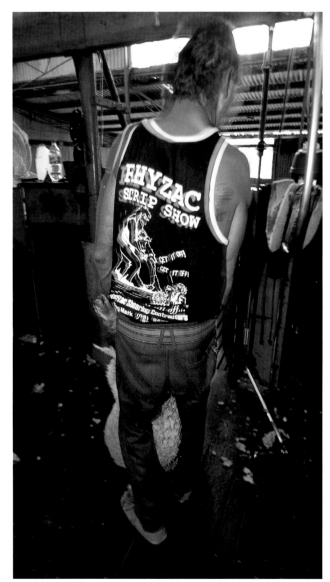

Outback shearer

A pen chock-full of cobblers is a shearer's dream of hell.

There's not much hope for the rouseabout.

By the time a Broomie reaches town with a few bob in his pocket he's a gun shearer!

The life is one of luxury, it's truly
 something grand
To be a roving shearer in Australia's
 Happy Land.

The only good sheep is a sheep down that porthole.

A shearer needs fuel.

Shearing, like cooking, makes men go mad.

The bloke who rings the board ain't always the fastest shearer in the shed.

Let the other fellow catch the last sheep in the pen.

No man labours as hard or lives as rough as the 40-hour-a-week shearer, whether he's wide-combing, narrow-combing or biting the wool off.

Get off the tube while you are young enough.

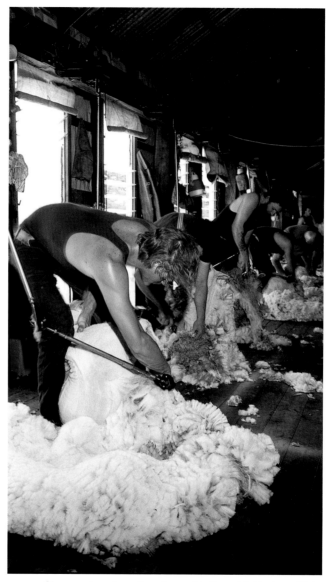

Sheep shearing, Rawlinna Station, Nullarbor Plain

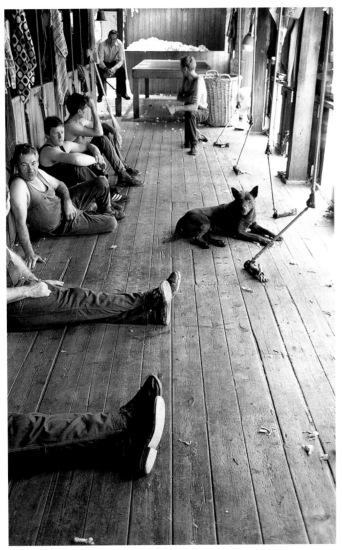

Tea break at the shearing shed, Queensland

And whether it is Toby, or Toss
 or Nell,
And whether it's wool or meat,
He will work all day, and night
 as well,
Till the pads wear off his feet.

Some of these smart kelpies can yard
chickens back into their egg-shells.

A top-notch barb can yard chickens
into a hat.

A cattle dog must bite and have no
tongue.

There're only two kinds of dogs
worth feeding. Sheep dogs and cattle
dogs, kelpies and blue-heelers.

The more I know of men, the more I admire dogs.

There's no dog more savage than the hybrid dingo.

A man looks such a fool without a dog.

A good cattle dog is worth as much as an ordinary stock horse.

Try it on the dog.

It ain't right t' touch another man's dawg.

Remember, a dog who will fetch will carry.

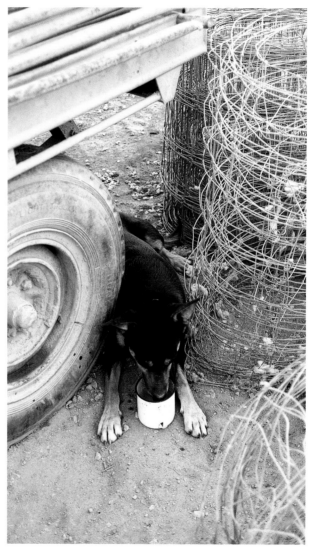

Dog's tea break

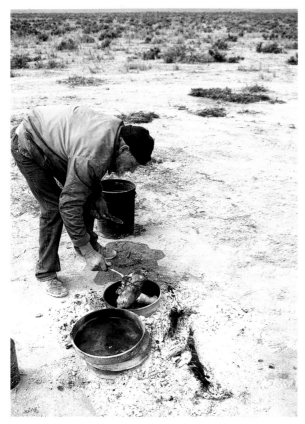
Cook with 'the roast' at a bush camp

I reckon this steak came from the Territory, and I reckon it walked all the way.

All shearers' cooks are mad. It's the continual heat on their guts that does it.

The men sometimes divide cooks into three classes—cooks, cuckoos and murderers.

No more puppy, no more pie.

A man is not considered a good bush cook unless he can make tasty soup out of a pair of old socks.

Cooks aren't people.

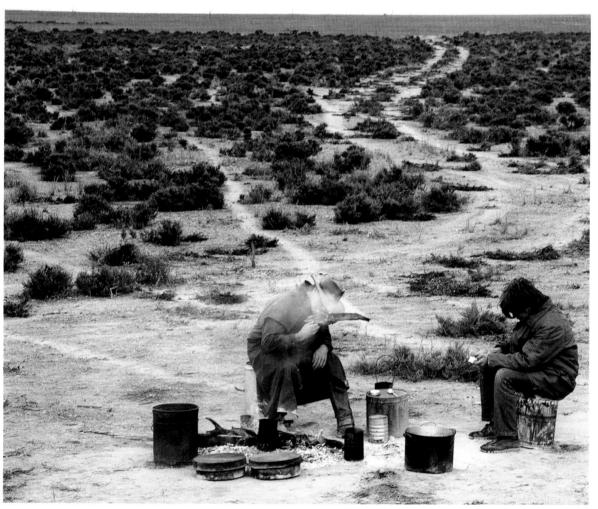

Tea break on the Nullarbor Plain, Western Australia

He was lazy
He was cheeky
He was dirty
He was sly
But he had a single virtue
And its name was rabbit pie

Rule 7 of the Swagman's Union:
Members who defame a good cook, or pay a
fine when run in, shall be expelled by the
union.

Who called the cook a bastard?
Who called the bastard a cook?

Men haven't a bit of taste 'cept for what's to
go in their stomachs.

A greasy chop an' a hunk o' bread an' y'
reckoned you were tuckerin' like a lord.

So fill up your tumbler as high as you can,
You'll never persuade me it's not the best
plan,
To let all the beers and spirits go free
And stick to my darling old billy of tea.

Billy tea is a milkless beverage flavoured
with eucalyptus and ants; it takes some
ability to make and some agility to drink.

That mutton's ay the sweetest which was
never bought nor sold.

Place a small roast and a big roast together
in the camp oven. When the small roast is
burnt the big roast is ready to eat.

Call me anything, but don't call me late for
dinner.

One word's as good as ten.
Wire in. Amen.

Eat away, chew away, munch and
 bolt and guzzle,
Never leave the table till you're full
 up to the muzzle.

D'yer call this tea? It's nothing but
innocent water scalded to death!

The Pearly Gates he'll open wide
and, sure enough, I'll see an angel
Aussie making up a fire for billy-tea.

When you have a good cook, your
battle is already won.

Never run out of boiling water.

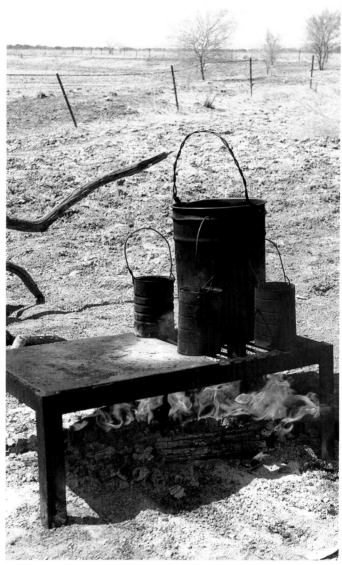

Boiling the billy

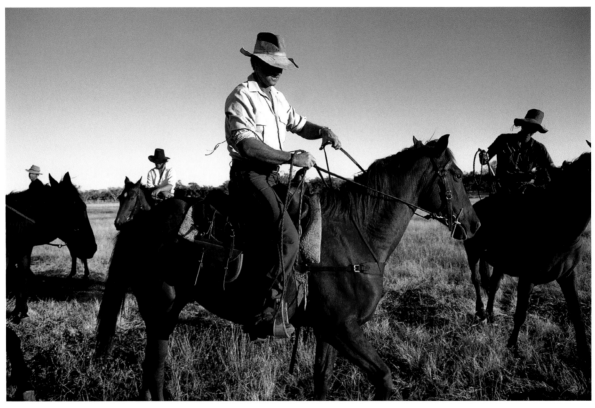

Mustering cattle in the Kimberley, Western Australia

I would rather be a boundary-rider than an Army General,
or a bullock-driver than an Under-Secretary.

Any man can knock bullocks about, but very few can drive them.

I'd sooner be a horse than a bullock.

No one ever yet drove bullocks without swearing.

They wouldn't steal a penny, But they'll all steal grass.

The world might wobble and all the banks go bung, but the cattle have to go through—that's the law of the stock-routes.

One big stampede to unnerve them, and the cattle are off every night, 'hell, west and crooked'.

Back-country milkers never forget their birthplace, and no river-fence will stop them making back there to calve.

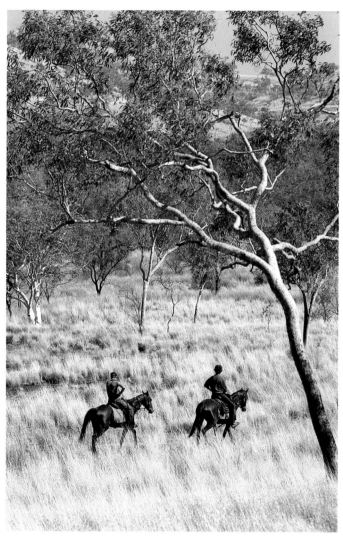

Stockmen in a Kimberley landscape

Stockwork in the big country is more by
instinct than command.

Don't be foolish in yards full of cattle.

A good drover is a man who does the best
for his cattle by day and his horses by night.

All good thoughts are won by walking.

You have no estimation
Of the great Australian nation,
Till you listen to a bullock-driver swear.

There are 2720 languages in use all over the
world, but the most expressive is that used
by the Australian Bullocky Bills.

A drover's life were dull but for
The wild flowers along the way.

I could write all he knows about cattle on
a fly's eye with a lump of charcoal!

Trust everyone, but brand your calves.

Honesty is the best policy, but never pass
an Ord River cleanskin.

Always sit down first and have a think. Boil
the billy, have a cuppa.

The greatest enjoyment under the sun
Is to sit by the fire till the beggars are done.

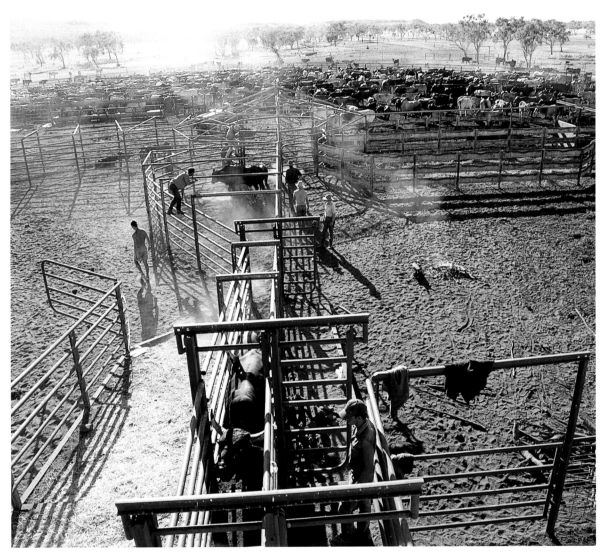

Branding cattle on a Kimberley station

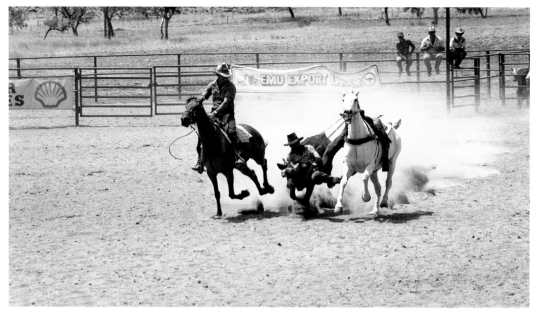

Favourite pastime in the bush

Bucking: the activities of that one horse in thousands which can be ridden only by one man in many thousands.

Getting off a bucking horse at the right moment is harder than sitting 'im.

Have you ever seen a camel really buck?

O, for foam-white shoulders
And the clink of snaffle-bars.

A prancing horse never wins anything.

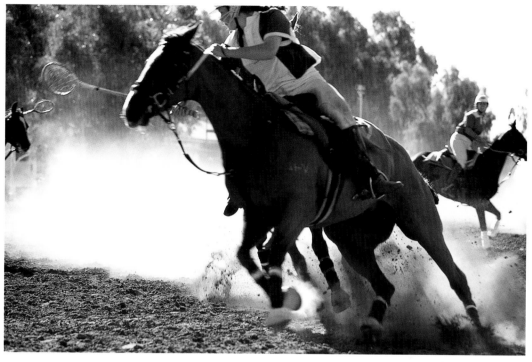

Bush polocross

Better to be killed off a buckjumper than be branded as a coward.

I've never known a horse that showed the whites of its eyes that wouldn't kick the eye out of a mosquito if it got half a chance.

Four white feet, send him right away.
Three white feet, keep him not a day.
Two white feet, sell him to a friend.
One white foot, keep him till the end.

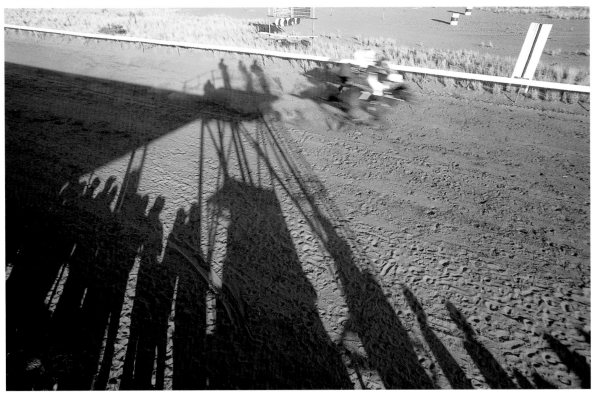
Horse racing at Gascoyne Junction, Western Australia

What after all is a bush race meeting without a fight or two?

You might have a champion horse, but you've still got to spell him going up a long hill.

The only bloke who ever made money following horses was a ploughman.

Horses for courses.

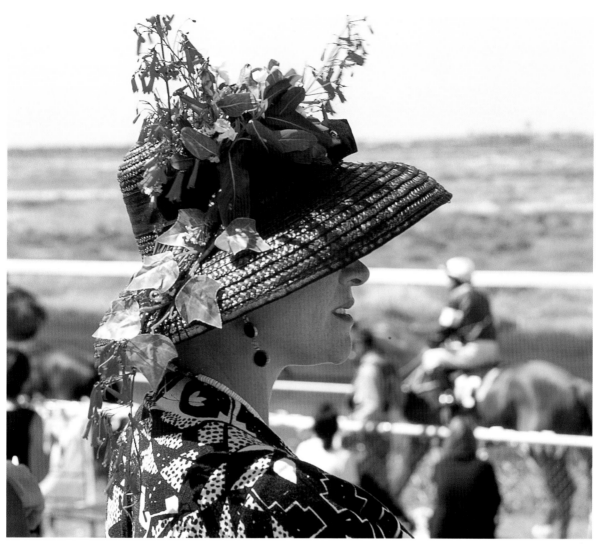

Dressed to kill, country races

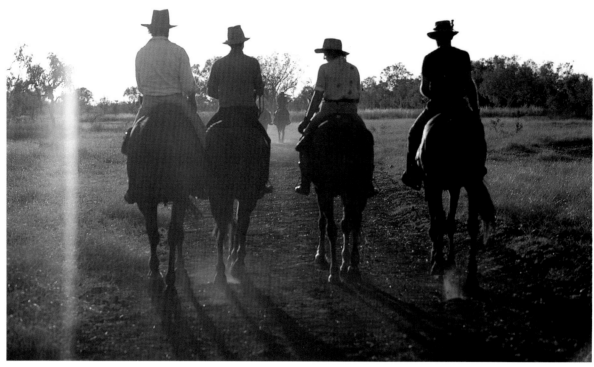

Kimberley stockmen head out for mustering

The' ain't a horse that wouldn't kick your brains out if yer had any.

A properly broken horse can be tied with cotton.

You can't shove a horse over a seven-foot fence.

Some slopes you ride down, you can't ride up.

Rest your hand on a good horse and the strength of him goes through you.

The reins of straining horses take all the strength out of you.

A horse is like a man—he's at his best when he gets a fair deal.

The horse that rolls completely over will bring an extra quid.

One light in the horse-paddock Is worth more than ten in the town.

Never give way to kindness. Keep the hand firm; the voice steady; and the heart where it ought to be—inside your shirt.

If you can ride him half a minute, you can ride him a week.

The redder the stallion, the more prone he is to eat up his keepers.

A prad which lies down at sunset is ailing.

A hobbled horse cannot swim.

But sweeter than those, the bushman knows, Is the bound of a good horse under.

It's surprising what you find to talk to a horse about.

Gee, Bob, or I'll sell ya.

Bush horses are expected to cut their own bread and butter.

Every man should spend an hour a day looking into a fire.

Do all your thinking before the light goes out.

Receive your thoughts as guests, but treat your desires as children.

A mallee-root fire loosens wit as wine does.

Always sling the billy when you see a stranger approaching.

Happiness is like a good digestion: avoid what doesn't agree with you and God takes care of the rest.

If you burn your bottom, you must sit on the blister.

Paint for marking stock

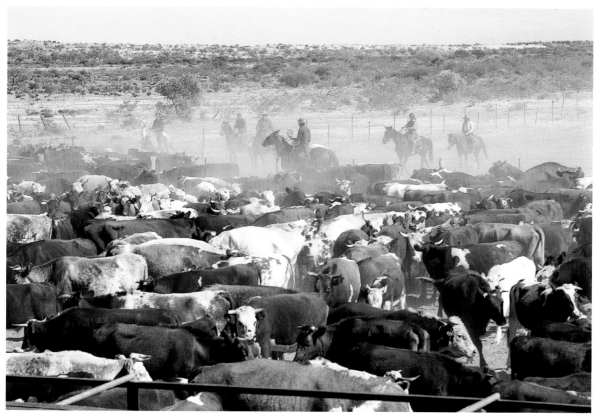

Mustering cattle

Bound'ry rid'n makes a man talk to his dog, talk to his sheep, talk to the bloody prickly pear.

This isn't cattle work—getting orf your horse every five minutes opening blasted gates!

You could yard a fly in a bottle on him.

Just be careful in the dunny. A red-back up your arsehole isn't funny.

Me old man, he taught me how to use an axe, but by crikey he never taught me how to like it.

The man who hasn't a male mate is a lonely man indeed, or a strange man, though he have a wife and family.

If the missus don't like you, the man won't keep you.

Why will the girls love and marry, when men are not worthy?

Women would know.

Never can He have known what it means to be a mother.

The hearts that made the nation were the women of the West.

There's no exception to the rule of bush hospitality.

Never let your tucker bags get low.

Hear the phantom songs of children, where the bush school used to be.

Harsh words cut like knives.

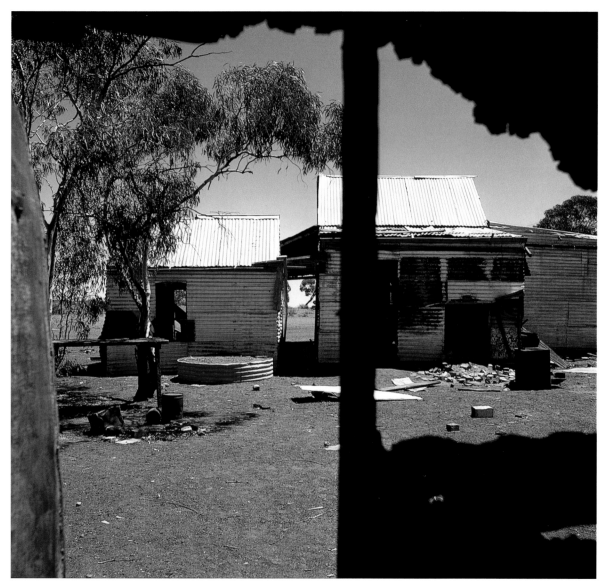

Ora Banda on the goldfields, Western Australia

I'm left without a stick at last,
To keep the pot a-boiling.

We all flinch at the cracking of whips.

It's the blokes that are too good yer
want ter watch.

A hint without evidence is a snake in
the grass.

I'd sooner be sad with the truth than
happy with a lie.

You don't fight a man; you fight the
world.

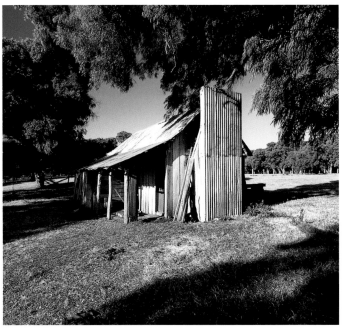

Pioneer cottage, Western Australia

What I've seen of it, you can't change
people.

Habits begin as cobwebs and end
up as chains.

Rough as bags, heart of gold.

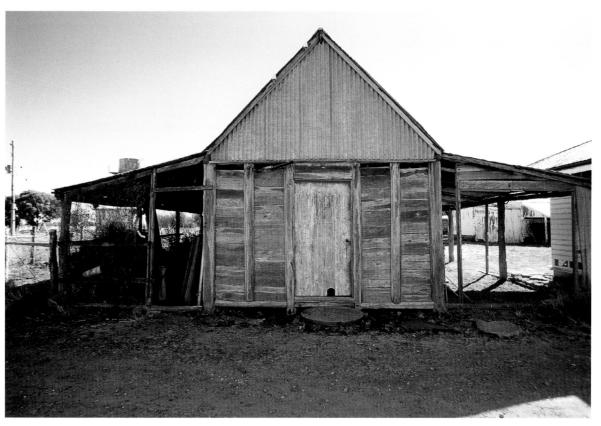

Timber slab building near Blackall, Queensland

*Most men judge their fellows by the
standards of their own craft.*

*Only men who treasure an axe guard its
edge so carefully.*

*Can't travel a hundred miles nowadays
without running into somebody!*

Things will be better after Christmas.

*Money is round to go around, and not to
hide away in boxes.*

Keep short arms and long pockets.

*Make money just as hard to spend as it was
to earn.*

*When neighbours come to borrow things,
Like smelling salts or teething rings,
Cross both your eyes and act insane—
Remark you think it looks like rain.*

If this be a town, what is a desert?

*Yer strike all kinds of loons in the bush an'
the worst is bush poets.*

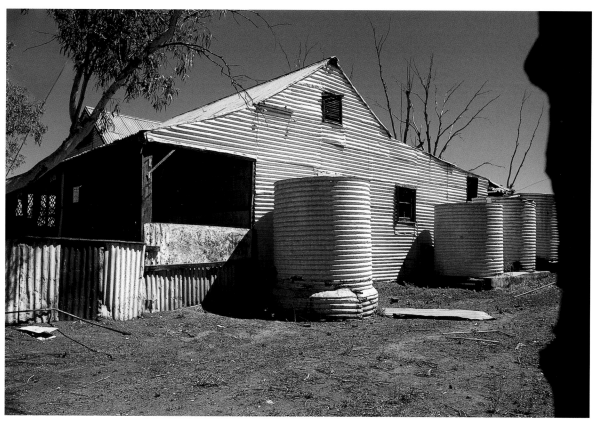

Corrugated-iron house and tanks near Kalgoorlie, Western Australia

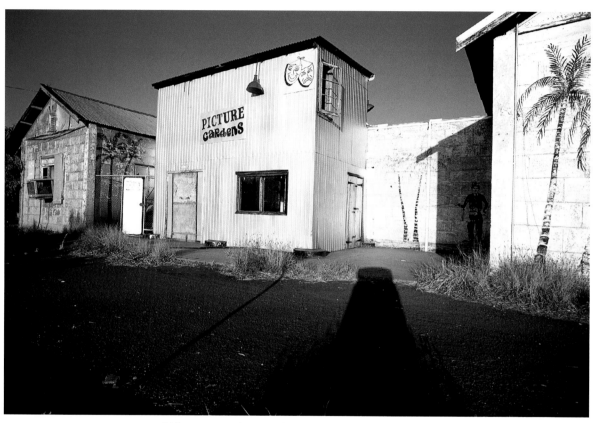

Wittenoom picture theatre, Western Australia

When you hear a snake yarn, multiply the breadth by the length and divide by ten.

No disgrace in bein' broke out 'ere.

Honest, hard-working men seem to accumulate the heaviest swags of trouble in this world.

Way back in Western Queensland, in the one-pub town of Bungaroo, the horses have hollow backs from passing under the sun.

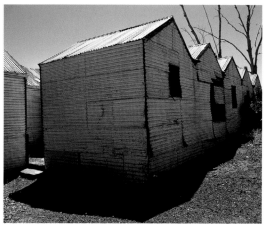

Workers' huts in a goldfields ghost town

Township—a store, an hotel, a post office, a blacksmith's shop, twenty-seven adults, seventy-five children, nineteen dogs, and Mrs Toole's pig.

Too many wowsers in these country towns. Bloke goes blue mouldy trying to keep alive in these country towns.

Where a woman is a woman, a man is a fool!

The best way to rid oneself of temptation is to succumb to it.

Don't drink with the flies.

Beer, Oh beer, I love thee;
In thee I place me trust:
I'd rather go to bed with hunger
Than go to bed with thust.

Beer makes you feel as you ought to feel
without it.

A man who doesn't drink is always well.
Miserable, but well.

Bush rum fires the imagination.

Life wasn't worth livin', an' maybe it ain't
when a man's real crook from the grog.

Who drinks tomorrow may thirst today.

Keep the dingoes off the front step.

He drinks hard, he works hard, and goes
to Hell at last.

Does a cool drink on a hot day ever seem
stale to you because you had one last time
you were thirsty?

The depression keeps you drinking.

The eyes of many lambed-down men
resemble each a star.

Drink makes a man an empty braggart or
a contented fool.

Goldfields pub at sunset, Western Australia

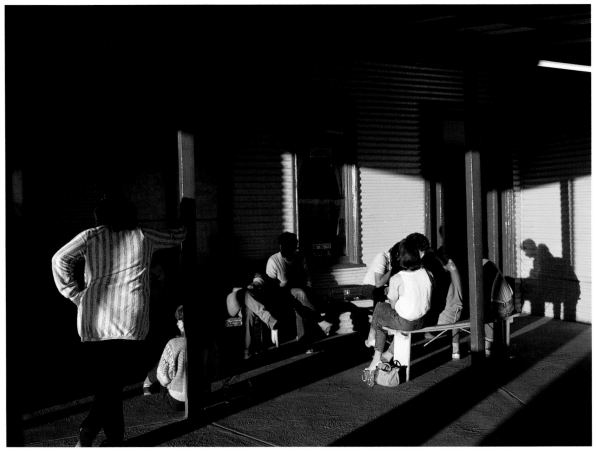

After-work drink at a country pub

Don't argue with a politician. You will only educate him.

A warning from a country pub: 'Paying guests taken by the day, week, or month. Those who don't pay taken by the neck'.

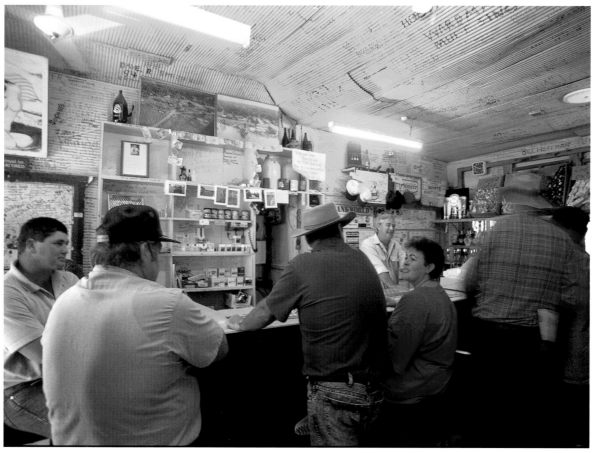

Tilpa pub, New South Wales

To create a joke, you first have a good laugh and then think backwards.

Make a joke and take a joke.

You might as well laugh.

The only reason I've had nine children by him is that I was hoping to lose him in the crowd.

Bush lawyers would argue for hours over any conceivable subject, if they could only get an audience patient enough to listen to them.

All men are lawyers in the bush.

A doctor is a doctor, but in the outside country he is a great deal more—or a great deal less.

It's the kid who never sees men grogging up who takes to it when he grows up.

A child is a man with his eyes open.

Never pass a boy without thinking about him.

You must be flat out, like a lizard drinking.

There's nothing solid in what ghosts drink.

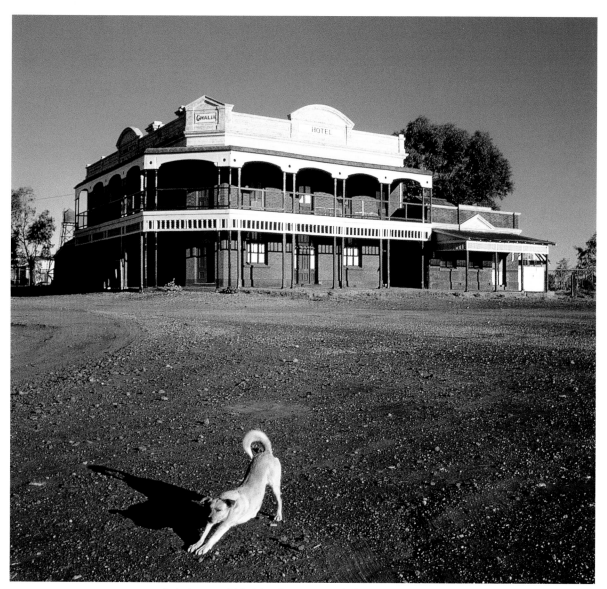

Pub in a goldfields ghost-town, Western Australia

A sign outside a roadside pub: 'Eat here or we'll both starve'.

A man gits dry, talkin'.

The right to poke a man's camp-fire is only earned after close friendship.

Never probe into a man's past.

A friend is a friend but a mate, well, he's you.

A mate can do no wrong.

Silence is the essence of mateship.

The wider the brim, the smaller the property.

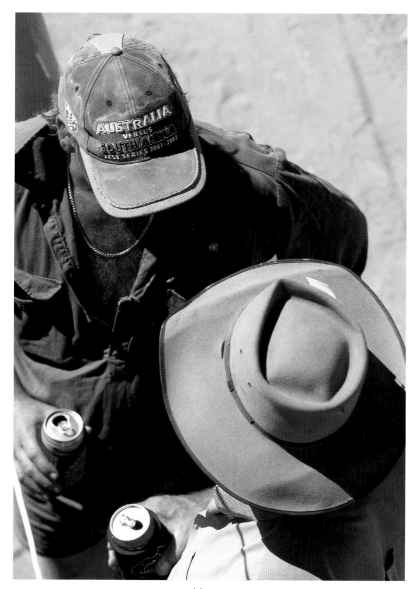

Mates

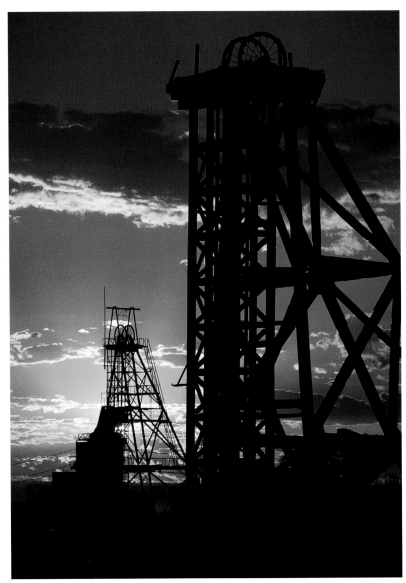

Timber poppet heads in the goldfields, Western Australia

A mine is a hole that is owned by a liar.

The best way to tell gold is to pass the nugget around a crowded bar, and ask them if it's gold. If it comes back, it's not gold.

Virgin gold bewitches.

Half the troubles of this world come from collections of specks like those.

Opals are bad luck.

No man's so poor he can't get into debt.

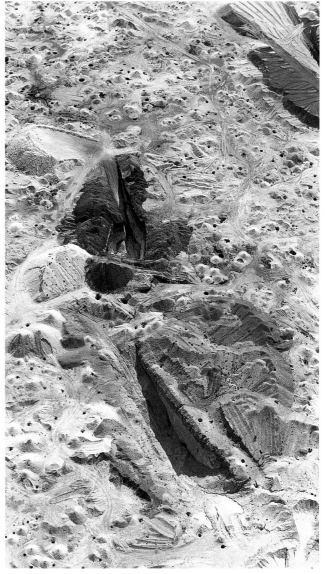

Opal diggings at Coober Pedy, South Australia

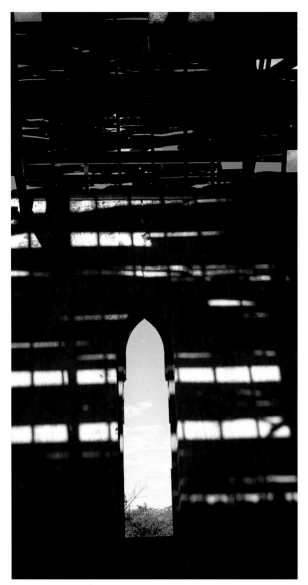

Derelict church at Greenough, Western Australia

We spend the first forty years of our lives trying to kill ourselves and the next forty trying to stay alive.

All I want in heaven is some sheep yards and a coil of wire.

Once they tell you you're in God's hands you know you're done.

The dead are truly forgotten only when their names are inscribed on public stone.

When I'm fit I ain't a bit religious. But when I'm crook, by thunder, then I gets very religious!

Wrap me up with my stock whip and bluey, And bury me deep down below.

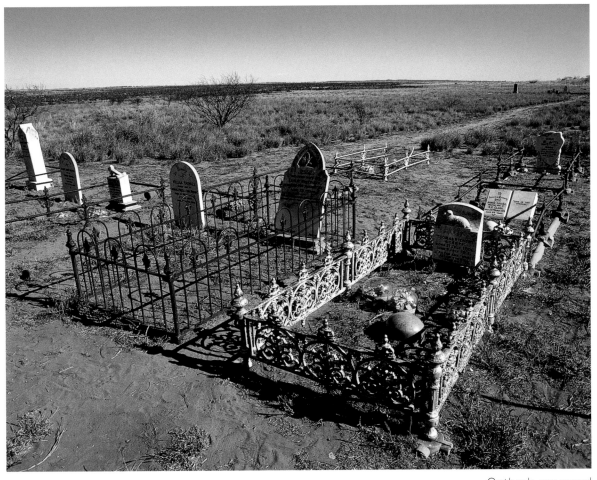

Outback graveyard

Where brown summer and Death have mated—that's where the dead men lie.

God has laid His own wild flowers on the lonely graves out West.

Where there's a will—there's a relative.

Become religious and be on the inside running.

If your neighbour takes religion, be sure to brand your calves as soon as you can.

There's Christians that would lamb you down and skin you for your last penny.

The average bishop loves the pure merinos of his flock.

If you're a sheep, it pays to be stud stock.

The priest is boundary-ridin' for the Pope.

*All your life
The tide is going out.*

Nothing soothes like the inevitable.

Fate is only waiting to do the decent thing.

If a bee is going to sting you, he'll sting you whether you strike at him or not.

You are bound to be crow's meat.

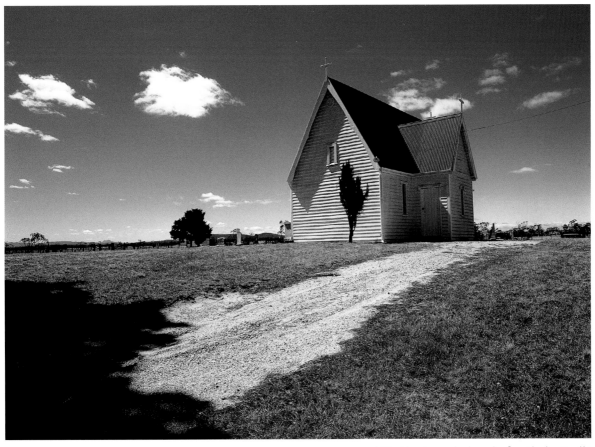

Weatherboard church, South Australia

Life is but a moment
That cheats the hand of Death.

The chances are I go where most men go.

I go where the last year's lost leaves go
At the falling of the year.

Them bastard crows, always waitin' fer
something to start to die.

I talk a lot to me dawg. An' them bastard crows.

Only ants and flies eat a dead crow.

Never say die till a dead horse kicks you.

Strangled by thirst and fierce privation—
That's how the dead men die.

The desert soon will take you
Back to her breast again.

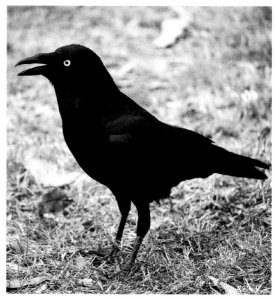

Australian raven, commonly called a crow

Out-bush our dead are all our own.

Before the majesty of death all quarrels cease, if only for a day.

We all quieten down as we grow older, perhaps because we all have more to be quiet about.

The Devil sent the squatter, and the Lord sent the rabbits to oust him,
and Bunny looks a winner.

It hurts yer deep to see an old mate go.

Old eyes so easily tire.

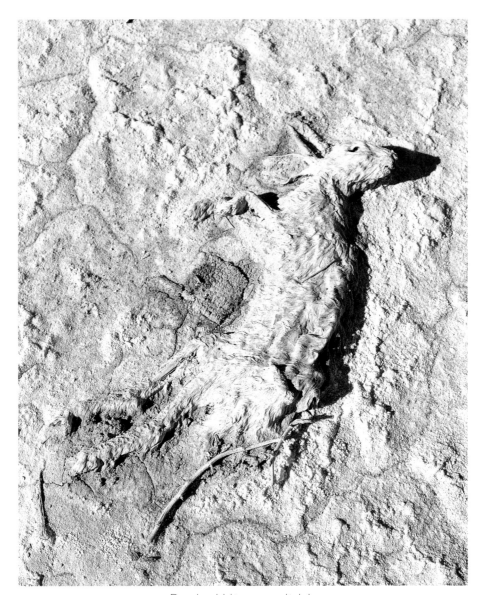
Dead rabbit on a salt lake

Remains, rabbit-proof fence, Nullarbor

Rabbit-proof netting is not any good. If the rabbits don't climb over, crawl under, or break through, the swaggie who wants work heaves them over.

Old men have sorrows that sons do not know.

The old go, the young go on.

You don't have to be dead to be stiff.

A thousand temples rise to Man for one that's built to God.

Good, better, best—never let it rest—till your
good is better—and your better, best.

If you're not always grateful for what you get,
Be thankful for what you escape!

A man don't know half.

A lotta things that ain't wrong ain't right
either.

You live an' learn, though the learning's not
much use.

Don't resign yourself to be a snoring corpse!

Mebbe there's a God who knows.

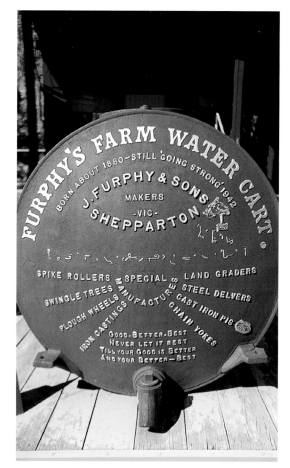

Furphy water tank
(Winton Museum, Queensland)

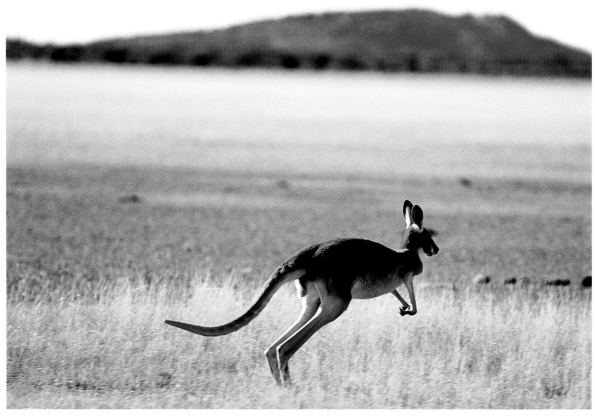

Red kangaroo

Hatters have kangaroos in the top paddock.

If it moves, catch it—it might be good tucker.

The rabbit scalper and his family very rarely eat rabbits.

Beyond the mythical Black Stump, the crows fly backwards to keep the sun and the flies out of their eyes.

Mob of emus

I hope all your chooks turn into emus and kick yer dunny down.

There's things that a man don't remember.

You could re-sole your boots with the breast meat of a brolga.

Select three average-sized stones, and place the plucked and gutted cockatoo or galah on top of them in a pot of water over a good fire. Boil hard for ten hours and then simmer for another five or six (the longer the better). Tip out the water, give the cockatoo to the dog, and eat the stones.

The only successful way to cook a galah is to get a farrier's rasp and file the galah to a powder. Mix with water and make a soup.

Dirt never clings to the wings of a bird.

The smallest of the bower birds builds the biggest bower.

Snakes ain't nothin'. Not if you treat 'em right.

There are times when you don't ask questions—you just eat.

Don't you worry; there's more than what you're welcome to.

How can one happy be
With bull-dog ants inside your hat,
And black ants in your tea?

The bull-dog ants get into your pants
And eat your Sunday socks!

A death-adder has it wrote on the inside of his skin that if only he wasn't deaf he wouldn't leave a man alive.

Squatting up in Queensland is a great mistake.

Outbackery has its intervals of excellence.

Crying babies should be like bushfires—put out.

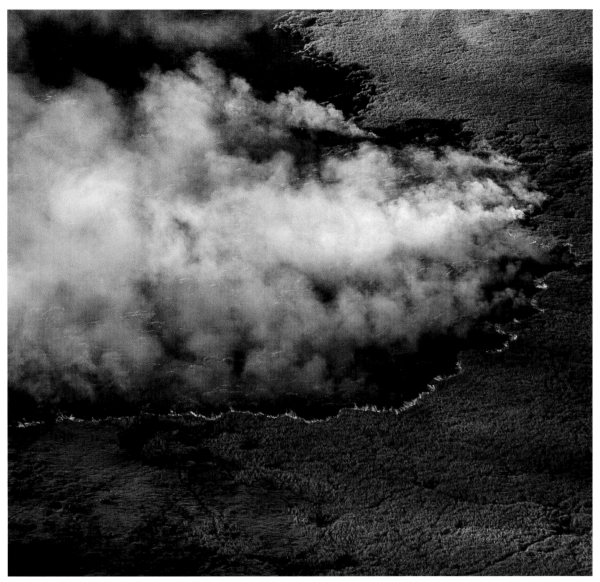

Bushfire in the Northern Territory

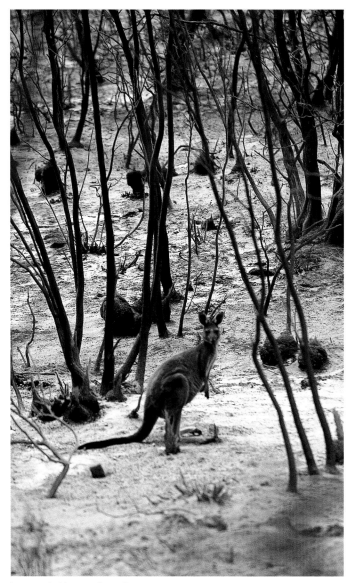

Lean pickings after fire

Blessed are the peacemakers, for they shall inherit a black eye.

When folks exclaim, 'It's all right', nine times out of ten it's all wrong.

It's never so bad that it couldn't be worse!

Life's a bastard, and we're all bastards together.

The experience is good, providing it doesn't last.

All madmen travel north.

The birds will sing again.

Karri forest regrowth after fire, Western Australia

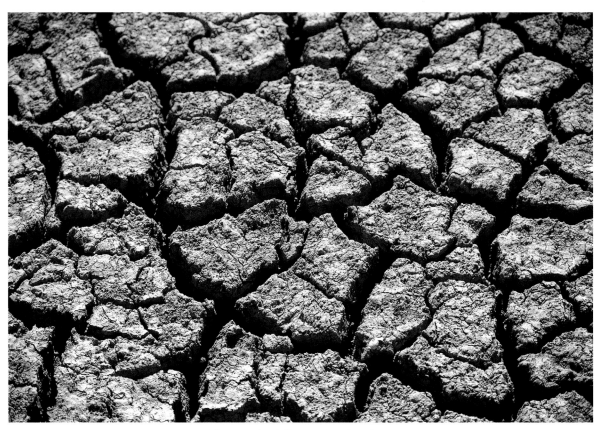

The cracked floor of a dry dam

If you don't give in, you're never beaten.

Failure has no case, and you can't build one for it.

It's a good thing to sweat well.

A drought starts as soon as the last drop of rain falls.

When the mulga starts to die, things are crook all right.

We could do with a drop of rain.

You could flog a flea across the paddocks, go home to dinner, and come back and still find him.

It's that dry here people think twice before they lick a postage stamp.

We might get some rain today—there are no clouds to stop it.

A Darling shower—three claps of thunder, two drops of rain and one dust storm.

It always rains and spoils a good drought.

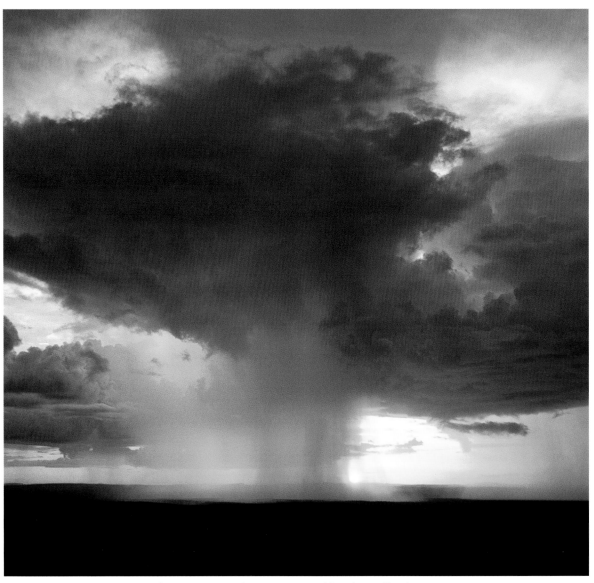

Storm approaches at sunset, Northern Territory

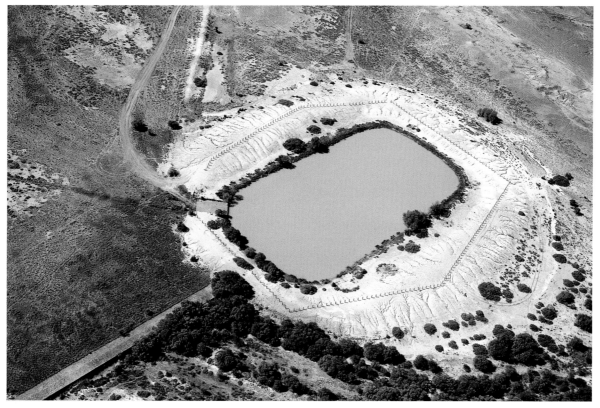

Don't pray for rain—dam it!

We're getting a day closer to rain ever' day.

Send 'er down, Hughie.

In some parts of Queensland two buckets of water and a frog would be called a lagoon.

I've stuck to Queensland up and down
But as far as I can see
It's only when it's wringing wet
That Queensland sticks to me

If you stick to the black soil when it's dry,
it'll stick to you when it's wet.

There's many a river that waters the land.

Nothing takes the conceit out of a
bumptious human quicker than a bull-ant.

You learn a lot in sixty years.

I wouldn't be dead for quids.

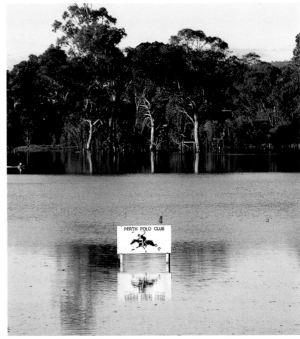

Flooded polo field at Guildford, Western Australia

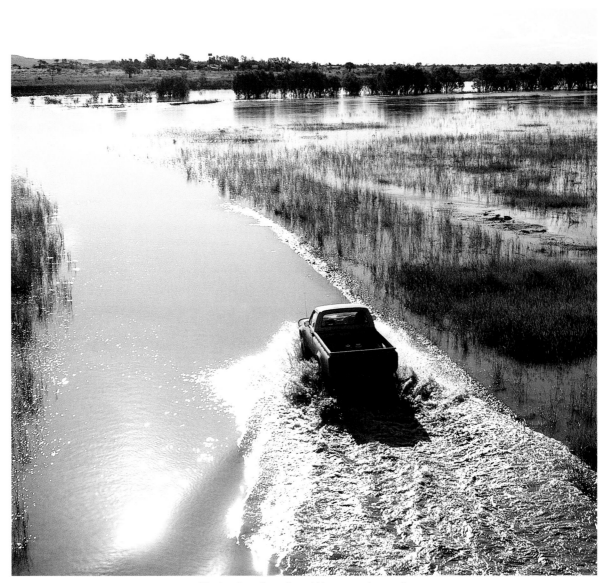

Kimberley flooding, Western Australia

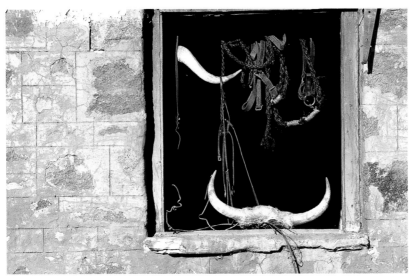

Outhouse window of a cattle station

A rooster today, a feather-duster tomorrow.

Most of the time, crow low and roost high.

I ain't met a word yet I can't read.

Words ain't much, whichever way you use them.

If we forget, we cease to be.

Wall of a slab building, New South Wales

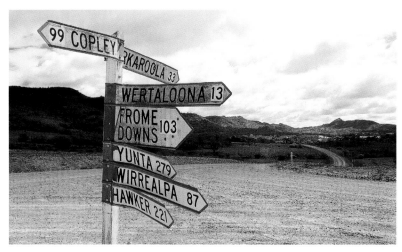

Remote signpost, South Australia

Source notes

We have occasionally edited the sayings—condensing, changing punctuation, regularising spelling and so on—and in doing so have adopted the spelling conventions of the *Macquarie Dictionary*. The source notes for the sayings on any one page follow the order of those sayings. Some of the sayings have kindly been provided by entrants in our bush wisdom contest (BWC).

Page 6
Ottley, *By the Sandhills of Yamboorah*, p. 111.
Don Anderson, *Bulletin*, 30 September 1972, p. 40.
Ross, *Australia '63*, p. 202.
Howcroft, *The Bushman Who Laughed Again*, p. 23.
Wannan, *Australian Folklore*, p. 261.
As above. Meaning 'all or nothing' (p.500). The *Australian National Dictionary* dates first usage to 1915.
Lawson, *While the Billy Boils*, p. 105. See also Roderick, *Henry Lawson: Short Stories and Sketches*, vol. 1, p. 580 fn.
Gilmore, 'The Waratah', *The Tilted Cart*, p. 67.
Bulletin, 16 April 1905, p. 19.
Ottley, *Brumbie Dust*, p. 48.
Howcroft, *This Side of the Rabbit Proof Fence*, p. 109.

Page 8
Ottley, *Brumbie Dust*, p. 28.
Newland, *Paving the Way*, p. 108.
Hill, *The Territory*, p. 425. The Cross is the Southern Cross (constellation Crux Australis). The *Australian National Dictionary* (p. 182) quotes *Blackwood's Magazine*, 1902: 'The position of the Cross will indicate plainly, even to minutes, the divisions of the night'—which is true; but one must first know its appropriate position for the hour, day and month, for its altitude changes by 30 degrees per month. Mark Twain said the Southern Cross would look exactly like a cross if a cross looked considerably different…
Ogilvie, *Fair Girls and Gray Horses*, p. 137.
Martin, *The Hero of Too*, p. 6.
Ottley, *By the Sandhills of Yamboorah*, p. 29.
Ellis, *The Long Lead*, p. 42.
Boldrewood, *Robbery Under Arms*, p. 149.
Hill, *The Territory*, p. 299.
Lewis, *Crow on a Barbed Wire Fence*, p. 70.

Page 10
Halcombe, *The Emigrant and the Heathen*, p. 45.
Bulletin, 12 August 1899, p. 14. A jackass is a kookaburra, whose dawn and dusk 'ha-ha'

resembles the 'hee-haw' of a male donkey (jackass).

Dick Dempster, 'Woronyne', Wongan Hills, Western Australia, conversation with Brian Dibble.

Howcroft, *The Bushman Who Laughed Again*, p. 56.

Emil Schatz, Gippsland area, as he abandoned a 17-acre settlement in 1905 (quoted in an exhibit, Museum of Victoria, Melbourne, December 1991).

Adam-Smith, *The Shearers*, p. xi.

Eastman, *Memoirs of a Sheepman*, p. 109. A pun on the unpromising name of the Melbourne store, Buckley and Nunn. Buckley's Chance is no chance, or two equally bad chances.

Page 12

Jim Gunn, 'Thungaby', St George, Queensland (BWC).

Underwood, *Crocodiles and Other People*, p. 72.

E. M. England, 'This Bare Brown Land' in Mackaness, *The Wide Brown Land*, p. 38. By courtesy of Annette Wythes (BWC), who recalled her father reading to her from old poetry books.

Page 14

Keesing, *The White Chrysanthemum*, p. 170.

Sharon Bowen, 'Braeburn', Binnaway, New South Wales (BWC).

Lewis, *Crow on a Barbed Wire Fence*, p. 59.

Macquarie Dictionary, p. 124.

McCarter, *Pan's Clan*, p. 138.

Bulletin, 21 October 1920, p. 22.

Wannan, *Dictionary of Australian Humorous Quotations and Anecdotes*, p. 147.

As above, p. 66.

Ottley, *Brumbie Dust*, p. 96.

Anon., 'The Old Bark Hut', in Stewart and Keesing, *Old Bush Songs and Rhymes of Colonial Times*, p. 24.

Page 16

'The Farmer Feeds Them All', 1890, from the Wrench family scrapbook, Mitchell Library, State Library of New South Wales; in Fahey, *When Mabel Laid the Table*, p. 39.

Cull, *At All Costs*, p. 10. A chat is British slang for a louse.

Ottley, *Rain Comes to Yamboorah*, p. 8.

Tritton, *Time Means Tucker*, p. 11.

Page 17

Lawson, 'How Steelman Told His Story', in Roderick, *Henry Lawson: Short Stories and Sketches*, vol. 1, p. 222.

Lawson, 'The Boss's Boots', in Roderick, *Henry Lawson: Collected Verse*, vol. 1, p. 320. In the gambling game of two-up, 'headin 'em' is betting that two coins tossed in the air will both land heads up. Sugar is money—perhaps from 'sugar bag', which is Aboriginal English for wild honey in a tree.

Farwell, *Land of Mirage*, p. 167.

Page 18

Truth, 26 April 1891, p. 3.

Walsh, *Pioneer Days*, p. 8.

Upfield, *Bony and the Mouse*, p. 28.

White, *Queensland the Progressive*, p. 27. Sheep are boxed, or in a 'mix-up' or a 'muddle a box', when flocks get mixed together.

'Sheepo', *Bulletin*, 6 September 1933, p. 24.

Sydney Morning Herald, 24 June 1843, p. 2.

Pastoral Review, March 1912 and October 1946; in Walsh, *Pioneer Days*, p. 211.

Page 20

Ronan, *Vision Splendid*, p. 291. A bagman is a swagman who sometimes rides a horse. The word

was probably 'a facetious application of bagman commercial traveller' (*Australian National Dictionary*).
Esmi, *Bulletin*, 6 July 1901, p. 14.

Page 21
Howcroft, *Sand in the Stew*, p. 36.
Walsh, *Pioneer Days*, p. 210.

Page 22
Wannan, *Modern Australian Humour*, p. 153.
Harmer, *It's a Joke, Joyce*, p. 9.
Marshall, *These Are My People*, p. 14.
Walsh, *Pioneer Days*, p. 216.
Carmichael, *The Warwick Edwards Collection*, p. 23.
Harney, *Content to Lie in the Sun*, p. 31.
Wannan, *Australian Folklore*, p. 226. This is a polite way of saying, 'You're sacked'.
J. Rankine, *Bulletin*, 6 January 1937, p. 20. 'Laughing-sides' are elastic-sided boots.
Adam-Smith, *The Shearers*, p. 195.
Baker, *The Australian Language*, p. 421. Used as early as 1583, the original meaning is clear from J. Ray's *English Proverbs* of 1670 (Simpson, *Concise Oxford Dictionary of Proverbs*, p. 124): 'What? keep a dog and bark myself. That is, must I keep servants, and do the work myself?'
Meredith, *Duke of the Outback*, p. 70.

Page 24
'Shearin' in the Bar', *Folklore Council*, p. 62. A cobbler is a difficult-to-shear sheep, commonly left until the last—a pun on 'cobbler's last'.
Edward S. Sorenson, 'Bill Brown', in Stewart and Keesing, *Australian Bush Ballads*, p. 221. A rouseabout is an unskilled worker in the shearing shed or on the station.
Adam-Smith, *The Shearers*, p. 151. A Broomie is someone who sweeps in the shearing shed, or a person from Broome on the Western Australian coast.
Edwards, *The Overlander Song Book*, p. 122.
Tracy Elliot-Reep, 'A Fair Clip' in *Pacific Way* (Air New Zealand in-flight magazine, Dec. 1991 / Jan. 1992), p. 66. The shearer pushes the just-shorn sheep through a porthole (or chute), which opens to a ramp into a pen outside the shed.

Page 25
Fahey, *When Mabel Laid the Table*, p. 20: 'At breakfast [Crooked Mick] would devour at least four sheep—six if they were weaners—two dozen eggs, thirty-three slices of bacon, fourteen large dampers, a gallon and a half of tea and, when they were available, three watermelons'. This mythic shearer grew so fast and big that 'his parents sent for a Wauchope woodchopper who ringbarked his ankles'.
Adam-Smith, *Folklore of the Australian Railwaymen*, p. 380.
Gumblegubbin', *Bulletin*, 8 October 1930, p. 20. To 'ring the board' is to shear the most sheep in a given period.
C. E. W. Bean, *On the Wool Track*, Sydney, 1925; in Wannan, *Australian Folklore*, p. 135.
People Magazine, 7 May 1984, p. 39. A comb is the toothed cutting end of a shearer's handpiece. Narrow combs were standard in Australia until New Zealand shearers introduced their controversial wide combs in the 1980s.
Sydney Morning Herald, 17 August 1963, p. 11. The downtube surrounds the flexible cable driving a shearer's blades.

Page 26

Pastoral Review, March 1912 and October 1946; in Walsh, *Pioneer Days*, p. 211.

Bulletin, 23 December 1915, p. 26.

Australian, 7 June 1923. A barb is a Kelpie dog, usually the black strain of the breed, especially valued for working sheep in yards. See Walsh, *Pioneer Days*, p. 56 for photographs of the famous Kelpie 'Coil' working a chick into a jam tin.

Truth, 4 March 1900, p. 5. Having no tongue means working without barking.

O'Grady, *Gone Troppo*, p. 4.

Page 27

Leonard Stone, 'History in Epitaphs', *Argus* (Melbourne), 12 February 1949; in Wannan, *Australian Folklore*, p. 210. Stone records an epitaph on a Bendigo tombstone, placed there by W. Webb, which reads in part: 'Erected in grateful remembrance of my faithful dog Fido, who died on March 28, 1904. A patient partner during 10 years of Life's journey, who had eaten the same bread with me and was to me a friend.' This sentiment is traditionally attributed to Mme de Sévigné, 1626–92 (Cohen, *The Penguin Dictionary of Quotations*, p. 308).

W. E., *Bulletin*, 30 September 1920, p. 24.

Bulletin, 22 July 1920, p. 20.

Walsh, *Pioneer Days*, p. 228.

Macquarie Dictionary, p. 96.

Ottley, *By the Sandhills of Yamboorah*, p. 100.

Nola Clarke, Bowral, New South Wales (BWC). This caution against gossiping was used as early as 1830 in East Anglia, UK (Simpson, *Concise Oxford Dictionary of Proverbs*, p. 58).

Page 28

Cato, *Green Grows the Vine*, p. 33.

Adam-Smith, *The Shearers*, p. 265.

Harney and Thompson, *Bill Harney's Cook Book*, p. 12.

Wannan, *Australian Folklore*, p. 149: a reference to cooks who used dogs for rabbit pie.

Wannan, *Australian Folklore*, p. 149.

Hungerford, *Riverslake*, p. 148.

Page 30

Australian Folklore Unit; in Fahey, *When Mabel Laid the Table*, p. 18.

Fahey, *When Mabel Laid the Table*, p. 44.

Originally from the English Army; in Fahey, *When Mabel Laid the Table*, p. 18. Cooks have been lampooned for centuries, as in this 1542 proverb: 'God may send a man good meat, but the devil may send an evil cook to destroy it' (Simpson, *Concise Oxford Dictionary of Proverbs*, p. 94).

Rudd, *On Our Selection and Our New Selection*, p. 107.

Stuart, *Wedgetail View*, p. 61

The Native Companion Songbook, Brisbane, 1889; in Fahey, *When Mabel Laid the Table*, p. 24.

Lingo, *The Australian Comic Dictionary of Words and Phrases*, p. 57.

Jenkin, *Songs of the Great Australian Balladists*, p. 72.

Fahey, *When Mabel Laid the Table*, p. 22.

Sharon Bowen, 'Braeburn', Binnaway, New South Wales (BWC).

Page 31

Wannan, *The Australian*, p. 6. A traditional shearer's grace.

Lindsay, *The Magic Pudding*, p. 22.

Aussie, April 1920, p. 20.

Jest, p. 37.

Harney and Thompson, *Bill Harney's Cook Book*, p. 11.
Marshall, *These Are My People*, p. 154.

Page 32
Upfield, *The Lure of the Bush*, p. 25.
Sidney, *A Voice from the Far Interior of Australia*, p. 48.

Page 33
Marshall, *I Can Jump Puddles*, p. 184.
Wannan, *My Kind of Country*, p. 40.
Murray Allison, 'The Grass Stealers', in Stewart and Keesing, *Australian Bush Ballads*, p. 24.
Lawson, 'Telling Mrs Baker' in Roderick, *Henry Lawson: Short Stories and Sketches*, vol. 1, p. 416.
Hill, *The Territory*, p. 295.
'Horseless Horseman', *Bulletin*, 26 January 1944, p. 13.

Page 34
Ottley, *Brumbie Dust*, p. 29.
Edwards, *Australian Folk Songs*, p. 65.
Walsh, *Pioneer Days*, p. 220.
Lindsay, *Age of Consent*, p. 13.
Truth, 9 June 1901, p. 3.
Truth, 11 January 1903, p. 1.
W. H. Ogilvie, 'A Wild-flower by the Way', 1899; in Melville, *The Australian Country Diary 1992*, p. 22. The reference is to girls, not flowers.
Hardie, *Cattle Camp*, p. 188.
Helen E. Allerton, 'Gleneda', Come-By-Chance, New South Wales (BWC).
Linklater, *Gather No Moss*, p. 100. A cleanskin is an unbranded animal.
Underwood, *Crocodiles and Other People*, p. 72.
Hill, *The Territory*, p. 108, quoting R. R. Knuckey. 'Beggars-in-the-pan' and 'a beggar on coal' are early terms for damper (*Australian National Dictionary*).

Page 36
'Sur Cingle', *Bulletin*, 20 December 1944, p. 12.
Coringa, *Bulletin*, 23 September 1920, p. 22.
O'Reilly, *Bowyangs and Boomerangs*, p. 139.
Ogilvie, *Fair Girls and Gray Horses*, p. 127. On a horse's bridle, the snaffle bars are the two parts of a jointed bit, which are joined by a small ring.
Marshall, *I Can Jump Puddles*, p. 89.

Page 37
Searcy, *By Flood and Field*, p. 250.
Marshall, *I Can Jump Puddles*, p. 81.
Wannan, *Australian Folklore*, p. 291. This version too is from *Australasian Post*, 18 January 1962:
One white foot, buy him.
Two white feet, try him.
Three white feet, look well about him.
Four white feet, do without him.
Wannan quotes Harold W. Thompson, *Body, Boots & Britches: Folktales, Ballads and Speech from Country New York* [1939] as saying he could not get an explication for an American version of the rhyme.

Page 38
Mullally, *Libra and the Leprechaun*, p. 142.
Marshall, *I Can Jump Puddles*, p. 139.
Edwards, *The Australian Yarn*, p. 219.
Martin, *The Hero of Too*, p. 106. A. E. T. Watson, *Turf*, 1891, p. vii explained that 'The Brighton Course is very like Epsom, and horses that win at one meeting often win at the other' (Simpson, *Concise Oxford Dictionary of Proverbs*, p. 115).

Page 40
Ottley, *Rain Comes to Yamboorah*, p. 76.

Ottley, *Brumbie Dust*, p. 34.
Ottley, *The Roan Colt of Yamboorah*, p. 96.
Ottley, *Brumbie Dust*, p. 33.

Page 41

Marshall, *I Can Jump Puddles*, p. 166.
As above, p. 199.
As above, p. 216.
Marshall, *These Are My People*, p. 18.
Edwards, *Australian Folk Songs*, p. 65.
Ottley, *Brumbie Dust*, p. 80.
'Central West', *Bulletin*, 5 August 1920, p. 26.
'Wessel', *Bulletin*, 21 October 1920, p. 20. In the bush, red cattle and horses are thought to be nervous or fractious, but red sheep dogs to have tougher feet than white-footed Border Collies.
Bulletin, 22 December 1943, p. 12. A prad is a horse, from 'paard', the Dutch word for horse.
Bulletin, 16 September 1920, p. 20.
Jenkin, *Songs of the Great Australian Balladists*, p. 60.
Ottley, *Brumbie Dust*, p. 22.

Page 42

Basil and Pat Sheahan, Roseworthy, South Australia.
Trollope, *Australia and New Zealand*, p. 261.
Marshall, *These Are My People*, p. 197.
Australian Country Life, 15 March 1911; in Melville, *The Australian Country Diary 1991*, p. 86.
Potted Wisdom and Happy Thoughts, p. 126.
Fullerton, *The Australian Bush*, p. 172.
Hornsby, *Old Time Echoes of Tasmania*, p. 25.
Martin, *The Hero of Too*, p. 349.
Mrs Harley Martin, Burrawang, New South Wales (BWC).

Page 43

Lewis, *Crow on a Barbed Wire Fence*, p. 56.

Hatfield, *Australia Through the Windscreen*, p. 85.
Britt, *Pardon My Boots*, p. 52.

Page 44

James, *Charles Charming's Challenges on the Pathway to the Throne*, p. 40.
Howcroft, *Sand in the Stew*, p. 71.
Lawson, 'Mateship', in Roderick, *Henry Lawson: Short Stories and Sketches*, vol. 1, p. 724.
Marshall, *These Are My People*, p. 158.
Barcroft Boake, 'Skeeta', *Old Bulletin Book of Verse*, p. 151.
Keesing, *The White Chrysanthemum*, p. 45.
As above, p. 141.
George Evans, 'The Women of the West'; in Newton, *The Second Bushwackers Australian Song Book*, p. 20.
Dorney, *An Adventurous Honeymoon*, p. 31.
Victor J. Daley, 'The Last Sundowner', *Lone Hand*, 1 October 1909; in Murray-Smith, *The Dictionary of Australian Quotations*, p. 257
Australian Bush Verse, p. 44.
'George Chanson', 'The Cove Whot Drives', in Stewart and Keesing, *Old Bush Songs and Rhymes of Colonial Times*, p. 152.

Page 46

Anon., 'An Old Hand's Chaunt', in Stewart and Keesing, *Old Bush Songs and Rhymes of Colonial Times*, p. 176.
Marshall, *This Is the Grass*, p. 98.
Harney, *Grief, Gaiety, and Aborigines*, p. 119.
Franklin, *All That Swagger*, p. 148.
Marshall, *I Can Jump Puddles*, p. 77.
Marshall, *This Is the Grass*, p. 74.
Ottley, *By the Sandhills of Yamboorah*, p. 116.
June Birkett, Coopernook, New South Wales (BWC).
Eldridge, *Walking the Dog and Other Stories*, p. 89.

Page 48

Martin, *The Hero of Too*, p. 8.

Marshall, *This Is the Grass*, p. 64.

Gunn, *We of the Never-Never*, p. 181.

Ray King, 'Riverview', Hillston, New South Wales (BWC).

Harney, *Grief, Gaiety, and Aborigines*, p. 185.

Johansen, *The Dinkum Dictionary*, p. 185.

Facey, *A Fortunate Life*, p. 106.

Howcroft, *The Old Working Hat*, p. 43.

Curr, *An Account of the Colony of Van Diemen's Land*, p. 50.

Bulletin, 1 August 1945, p. 12.

Page 51

Paul Wenz, *Diary of a New Chum*, 1908; in Melville, *The Australian Country Diary 1992*, p. 24.

Lewis, *Crow on a Barbed Wire Fence*, p. 78.

Lawson, 'They Wait at the End of the Wharf in Black', in Roderick, *Henry Lawson: Short Stories and Sketches*, vol. 1, p. 283.

Bulletin, 22 July 1920, p. 22.

Lingo, *The Australian Comic Dictionary of Words and Phrases*, p. 16.

Lindsay, *Age of Consent*, p. 26. 'Wowser' has a dramatic origin. John Norton, editor of *Truth*, claimed to have invented the word in the 1890s: 'I first gave it public utterance in the City Council, when I applied it to Alderman Waterhouse, whom I referred to…as the white, wooly, weary, word-wasting wowser from Waverly'. Norton felt the term would 'at once describe, deride, and denounce that numerous, noxious, pestilent, puritanical, kill-joy push—the whole blasphemous, wire-whiskered brood' (W. S. Ransom, 'The Historical Study of Australian English', *Macquarie Dictionary*, p. 60).

'The Snowy River Roll', *Folklore Council of Australia*, p. 82.

Howcroft, *The Clancy That Overflowed*, p. 11. It recalls Oscar Wilde (Lord Darlington in *Lady Windemere's Fan*), 'I can resist everything except temptation', and Mae West (in *My Little Chickadee*), 'I generally avoid temptation unless I can't resist it'.

Page 52

Wannan, *Bill Wannan's Folklore of the Australian Pub*, p. 67.

Anon., in Fahey, *When Mabel Laid the Table*, p. 78.

Kodak, 'Two Happy Men', *Bulletin*, 8 January 1920, p. 16.

Rod Meakins, Bullsbrook, Western Australia, conversation with Brian Dibble.

Truth, 9 April 1905, p. 1.

Stuart, *Wedgetail View*, p. 33.

Jenkin, *Songs of the Great Australian Balladists*, p. 88.

Baker, *The Australian Language*, p. 421, meaning 'Keep the wolf away from the door'.

From 'Click Go the Shears'; in Edwards, *The Overlander Song Book*, p. 110. In another version (p. 111), the line ends 'and goes broke at last'.

Hatfield, *Sheepmates*, p. 235. Noted interpretation: 'On seeing beauty in a lovely night, even after having seen many of them'.

Adam-Smith, *The Shearers*, p. 309.

R. Cassidy, 'A Two-sided Idyll', *Bulletin*, 9 April 1914, p. 22. To lamb-down is to attend to sheep at lambing time; colloquially, it means to con someone, in this case into spending money on drink.

Wannan, *Bill Wannan's Folklore of the Australian Pub*, p. 3.

Page 54
Betty-Grace Ross, 'Westmoor', Warwick, Queensland (BWC).
Potted Wisdom and Happy Thoughts, p. 124.

Page 55
Wannan, *Dictionary of Australian Humorous Quotations and Anecdotes*, p. 85.
Lewis, *Crow on a Barbed Wire Fence*, p. 78.
Willey, *You Might as Well Laugh Mate*, p. vii.

Page 56
Harmer, *It's a Joke, Joyce*, p. 9.
Haydon, *Sporting Reminiscences*, p. 117. A sentiment evident as early as 1835 (*The Australian National Dictionary*, p. 120).
Baker, *The Australian Language*, p. 421.
Underwood, *Crocodiles and Other People*, p. 72.
Marshall, *I Can Jump Puddles*, p. 162.
Marshall, *This Is the Grass*, p. 81.
James Ralph Darling, 'Maxims of a Headmaster', in Murray-Smith, *The Dictionary of Australian Quotations*, p. 59.
Gray, *Drive a Hard Bargain*, p. 10.
Bulletin, 5 January 1943, p. 12.

Page 58
Seen by Brian Dibble in the southwest of Western Australia.
Ottley, *Brumbie Dust*, p. 41.
Marshall, *These Are My People*, p. 186.
Meredith, *Duke of the Outback*, p. 124.
Meredith, *Duke of the Outback*, p. 81.
Hardy, *The Yarns of Billy Borker,* p. 80.
Bulletin, 21 January 1986, p. 36.
McGregor, *The Australian People*, p. 181.

Page 61
Edwards, *The Overlander Song Book*, p. 194.
Lennie Lower, 'What Gold Is', *Here's Another*, Sydney, 1939; in Murray-Smith, *The Dictionary of Australian Quotations*, p. 164.
Meredith, *Duke of the Outback*, p. 85.
Marshall, *These Are My People*, p. 39.
Baker, *The Australian Language*, p. 421.
Hardy, *The Yarns of Billy Borker*, p. 53.

Page 62
Don McKenzie, Myrtleville, New South Wales (BWC).
Marshall, *These Are My People*, p. 9.
Marshall, *I Can Jump Puddles*, p. 7.
Martin, *The Hero of Too*, p. 7.
Howcroft, *Sand in the Stew*, p. 36.
Frank Sims's version of 'The Dying Stockman'; in Edwards, *The Australian Yarn*, p. 105. A bluey is a rough woollen blue-grey overcoat. Henry Lawson said blue was preferred for not showing dirt; others refer to a brand of coat made in Tasmania.

Page 63
Jenkin, *Songs of the Great Australian Balladists*, p. 75.
As above, p. 55.

Page 64
Denis Pitt, Warners Bay, New South Wales (BWC).
Harney, *Grief, Gaiety, and Aborigines*, p 119.
Kidman, *On the Wallaby*, p. 139.
Fetherstonhaugh, *After Many Days*, p. 390.
'Stony', *Bulletin*, 26 September 1907, p. 13.
Ottley, *Jim Grey of Moonbah*, p. 64.
Bulletin, 19 August 1899, p. 15.
Edwards, *The Overlander Song Book*, p. 233.

Wannan, *Dictionary of Australian Humorous Quotations and Anecdotes*, p. 88.

Lindsay, *Age of Consent*, p. 186.

Marshall, *These Are My People*, p. 193.

Robert Bruce, 'Verdant Green and the Crow', in Stewart and Keesing, *Australian Bush Ballads*, p. 95.

Page 65

Ogilvie, *Fair Girls and Gray Horses*, p. 121.

Gordon, 'The Sick Stockrider', *Bush Ballads and Galloping Rhymes*, p. 122.

Gordon, 'A Song of Autumn', as above, p. 177.

Page 66

Lewis, *Crow on a Barbed Wire Fence*, p. 158.

As above, p. 158.

As above, p. 159.

J. Baines, Wauchope, New South Wales (BWC).

Barcroft Boake, 'Where the Dead Men Lie', in Stewart and Keesing, *Australian Bush Ballads*, p. 95.

Dorham Doolette, 'The Old Coolgardie Road', in Stewart and Keesing, *Australian Bush Ballads*, p. 111.

Gunn, *We of the Never-Never*, p. 163.

Martin, *The Hero of Too*, p. 356.

Potted Wisdom and Happy Thoughts, p. 129.

Truth, 22 July 1906, p. 1.

Ottley, *Rain Comes to Yamboorah*, p. 56.

A. G. Stephens, 'The Honeymoon Trail', *Old Bulletin Book of Verse*, p. 197.

Page 68

'Chas F', *Bulletin*, 28 April 1900, p. 14.

Lawson, 'There's a Bunk in the Humpy', Stewart and Keesing, *Old Bush Songs and Rhymes of Colonial Times*, p. 195.

Martin, *The Hero of Too*, p. 347.

Baker, *The Australian Language*, p. 421.

'P. Luftig', 'Life's Paradoxes', *Old Bulletin Book of Verse*, p. 85.

Page 69

These words were cast onto the ends of the water tanks produced by the Shepparton foundry of J. Furphy and Sons from 1895. The rhyme may be by John Furphy (Pilbeam, *The First Hundred Years* p. 17; Opie, *The Oxford Book of Children's Verse*, p. 14).

Howcroft, *The Old Working Hat*, p. 6.

Ottley, *By the Sandhills of Yamboorah*, p. 48.

Marshall, *I Can Jump Puddles*, p. 179.

Ottley, *Brumbie Dust*, p. 119.

Hatfield, *Sheepmates*, p. 139.

Bernard Espinasse, 'Dunno', *Old Bulletin Book of Verse*, p. 137.

Page 70

Wannan, *Australian Folklore*, p. 322.

Fahey, *When Mabel Laid the Table*, p. 13.

Davidson, *Tales of the Tambo Valley*, p. 42.

Page 71

Maitland, *Breaking Out*, p. 83.

Daily Mirror, 12 October 1972, p. 4.

Ottley, *By the Sandhills of Yamboorah*, p. 95.

Lockwood, *My Old Mates and I*, p. 133.

Wannan, *Australian Folklore*, p. 138.

World News, in Fahey, *When Mabel Laid the Table*, p 10.

Marshall, *This Is the Grass*, p. 19.

Schodde and Tidemann, *Reader's Digest Complete Book of Australian Birds*, p. 588.

Page 72

Ottley, *Brumbie Dust*, p. 36.

As above, p. 41.

Baker, *The Australian Language*, p. 94.
Thatcher, *Something to His Advantage*, p. 124.
Wannan, *Australian Folklore*, p. 167.
Mick the Preacher, *Bulletin*, 15 July 1920, p. 20.
'Remos', from 'Squatting in Queensland', Stewart and Keesing, *Old Bush Songs and Rhymes of Colonial Times*, p. 202.
Ronan, *Once There Was a Bagman*, p. 124.
Baker, *The Australian Language*, p. 421.

Page 74
Wannan, *Dictionary of Australian Humorous Quotations and Anecdotes*, p. 121.
Thatcher, *Colonial Songster*, p. 30.
Edna Promnitz, 'Tremayne', Bellata, New South Wales (BWC).
Martin, *The Hero of Too*, p. 324.
Barbara Murray, 'Treheath', Kyogle, New South Wales (BWC).
Wannan, *My Kind of Country*, p. 2.
Sheila Goodacre, Canowindra, New South Wales (BWC).

Page 77
Marshall, *I Can Jump Puddles*, p. 106.
Lawson, 'How Steelman Told His Story', *While the Billy Boils*, p. 293.
Rudd, *On Our Selection and Our New Selection*, p. 76.
M. Carter, Quirindi, New South Wales (BWC).
O'Grady, *Gone Troppo*, p. 9.
Porteous, *Cattleman*, p. 233.
Wannan, *Fair Go, Spinner*, p. 79.

F. Noll, 'Karinya', Condobolin, New South Wales (BWC).
Betty-Grace Ross, 'Westmoor', Warwick, Queensland (BWC).
S. E. Yarra, 'King Charlie Rain-maker', *Bulletin*, 14 December 1955; in Wannan, *Australian Folklore*, p. 175.
Betty-Grace Ross, 'Westmoor', Warwick, Queensland (BWC).

Page 79
Wannan, *My Kind of Country*, p. 2.
Mary Lia, Cambridge Park, New South Wales (BWC).
Wannan, *Australian Folklore*, p. 465.
Nicholson, *The Opal Fever*, p. 32.

Page 80
Fahey, *When Mabel Laid the Table*, p. 85.
John Day, 'Wonga', Tottenham, New South Wales (BWC).
'Down by the Tambo', *Folklore Council*, p. 80.
Australian Writer's Annual, 1936, p. 31.
Marshall, *These Are My People*, p. 162.
Darvel Baird, 'Karoo', Wellington, New South Wales (BWC).

Page 82
Wilkes, *A Dictionary of Australian Colloquialisms*, p. 171.
Lawson, *While the Billy Boils*, p. 292.
Marshall, *These Are My People*, p. 196.
Ottley, *By the Sandhills of Yamboorah*, p. 170.
Harney and Elkin, *Songs of the Songmen*, p. 42.

Bibliography

A detailed discussion of these sayings appears in Brian Dibble, 'Australian Bush Wisdom and the Australian Legend' in Perry Share (ed.), *Beyond Countrymindedness: Communications, Culture and Ideology in Rural Areas*, Wagga Wagga, Charles Sturt University Press, 1995, pp. 24–34.

Adam-Smith, Patsy, *Folklore of the Australian Railwaymen*, Adelaide, Rigby, 1976.
—— *The Shearers*, Melbourne, Thomas Nelson, 1982.
Australian Bush Verse: Selected from The Bronze Swagman Book of Bush Verse, Sydney, Ure Smith, 1976.
Australian National Dictionary, The, see Ransom
Baker, Sidney J., *The Australian Language*, Melbourne, Sun Books, 1966.
Boldrewood, Rolf, *Robbery Under Arms*, London, Oxford University Press, 1888.
Britt, Margaret, *Pardon My Boots*, Sydney, Humorbooks, 1966.
Cable, Boyd (pseud. for Ernest Andrew Ewart), *By Blow and Kiss: The Love Story of a Man with a Bad Name,* 2nd edn, London, 1914.
Carmichael, Leigh (ed.), *The Warwick Edwards Collection*, York, WA, Saltbush Productions, 1991.
Cato, Nancy, *Green Grows the Vine*, London, Heinemann, 1960.
Cohen, J. M. and M. J. (eds), *The Penguin Dictionary of Quotations*, London, Jonathan Cape, 1962.
Cull, Ambrose W., *At All Costs*, Melbourne, Australasian Authors' Agency, 1919.

Curr, Edward, *An Account of the Colony of Van Diemen's Land*, Hobart, Platypus Publications, 1967.
Davidson, W. H., *Tales of the Tambo Valley*, Sydney, B. R. and H. F. Davidson, 1981.
Davison, F. D. and B. Nicholls, *Blue Coast Caravan*, Sydney, 1935.
Delbridge, A. (ed.), *Macquarie Dictionary*, 2nd edn, Sydney, Macquarie Library, 1984.
Dorney, Muriel, *An Adventurous Honeymoon: The First Motor Honeymoon Around Australia*, Brisbane, J. Dorney, 1927.
Eastman, Hugh M., *Memoirs of a Sheepman*, Deniliquin, NSW, self-published, 1953.
Edwards, Ron, *The Overlander Song Book*, Adelaide, Rigby, 1971.
—— *Australian Folk Songs*, Holloways Beach, Qld, Rams Skull Press, 1972.
—— *The Australian Yarn*, Adelaide, Rigby, 1977.
Eldridge, Marian, *Walking the Dog and Other Stories*, Brisbane, University of Queensland Press, 1984.
Ellis, M. H., *The Long Lead*, London, T. Fisher and Unwin, 1927.
Facey, A. B., *A Fortunate Life*, Melbourne, Viking, 1985.

Fahey, Warren, *When Mabel Laid the Table: The Folklore of Eating and Drinking in Australia*, Sydney, State Library of NSW Press, 1992.

Farwell, George, *Land of Mirage*, Adelaide, Rigby, 1950.

Fetherstonhaugh, Cuthbert, *After Many Days*, Melbourne, E. W. Cole, 1917.

Folklore Council of Australia, *Australian Folk Songs of the Land and Its People*, Kilmore, Vic., Lowden Publishing, 1977.

Franklin, Miles, *All That Swagger*, Sydney, Angus and Robertson, 1940.

Fullerton, Mary E., *The Australian Bush*, London, J. M. Dent and Sons, 1928.

Gilmore, Mary, *The Tilted Cart*, Sydney, privately printed, 1925.

Gordon, Adam Lindsay, *Bush Ballads and Galloping Rhymes: The Poetical Works of Adam Lindsay Gordon*, Melbourne, Lloyd O'Neil, 1980.

Gray, Oriel, *Drive a Hard Bargain*, Hobart, Tasmanian Adult Education Board, 1958.

Gunn, Mrs Aeneas, *We of the Never-Never*, London, Hutchison, 1908.

Halcombe, J. J., *The Emigrant and the Heathen*, London, 1874.

Hardie, J. J., *Cattle Camp*, Sydney, Frank C. Johnson, 1932.

Hardy, Frank, *The Yarns of Billy Borker*, Sydney, A. H. and A. W. Reed, 1965.

Harmer, Wendy, *It's a Joke, Joyce: Australia's Funny Women*, Sydney, Pan, 1989.

Harney, W. E., *Content to Lie in the Sun*, London, Robert Hale, 1958.

—— *Grief, Gaiety, and Aborigines*, Adelaide, Rigby, 1961.

Harney, W. E. and A. P. Elkin (eds), *Songs of the Songmen: Aboriginal Myths Retold*, Melbourne, F. W. Cheshire, 1949.

Harney, W. E and Patricia Thompson, *Bill Harney's Cook Book*, Adelaide, Rigby, 1972.

Hatfield, William, *Australia Through the Windscreen*, Sydney, Angus and Robertson, 1941.

—— *I Find Australia*, London, Oxford University Press, 1946.

—— *Sheepmates*, Sydney, Angus and Robertson, 1946.

Haydon, T., *Sporting Reminiscences*, London, 1898.

Hesling, Bernard, *The Dinkumization and Depommification of the Artful English Immigrant*, Sydney, Ure Smith, 1963.

Hill, Ernestine, *The Territory*, Sydney, Walkabout Pocketbooks, 1951.

Hornsby, M., *Old Time Echoes of Tasmania*, Hobart, 1896.

Howcroft, Wilbur G., *This Side of the Rabbit Proof Fence*, Melbourne, Hawthorn Press, 1971.

—— *The Clancy That Overflowed*, Melbourne, Sirius Publications, 1971.

—— *Sand in the Stew*, Melbourne, Hawthorn Press, 1974.

—— *The Old Working Hat*, Melbourne, Hawthorn Press, 1975.

—— *The Bushman Who Laughed Again*, Melbourne, Hutchinson Group, 1983.

Hungerford, T. A. G., *Riverslake*, Sydney, Angus and Robertson, 1953.

James, Clive, *Charles Charming's Challenges on the Pathway to the Throne*, London, Jonathan Cape, 1981.

Jenkin, Graham, *Songs of the Great Australian Balladists*, Adelaide, Rigby, 1978.

Jest: A Digest-ion of Good Humour, Sydney, Frank Johnson, 1943.

Johansen, Lenie (Midge), *The Dinkum Dictionary*, Melbourne, Viking O'Neil, 1988.

Keesing, Nancy (ed.), *The White Chrysanthemum: Changing Images of Australian Motherhood*, Sydney, Angus and Robertson, 1977.

Kennedy, Victor, *By Range and River: In the Queensland Tropics*, Cairns, The Cairns Post, 1930.

Kidman, Bill, *On the Wallaby*, Sydney, Walsh, l974.

Lawson, Henry, *While the Billy Boils*, Melbourne, Lloyd O'Neil, 1970.

Lewis, Harold, *Crow on a Barbed Wire Fence*, Sydney, Angus and Robertson, 1973.

Lindsay, Norman, *Age of Consent*, London, Werner Laurie, 1938.

—— *The Magic Pudding*, Sydney, Angus and Robertson, 1973.

Lingo, Turner O., *The Australian Comic Dictionary of Words and Phrases*, Melbourne, E. W. Cole Book Arcade, 1916.

Linklater, William and Lynda Tapp, *Gather No Moss*, Melbourne, Macmillan, 1968.

Lockwood, Douglas, *Crocodiles and Other People*, London, Cassell, 1959.

—— *My Old Mates and I*, Adelaide, Rigby, 1979.

McCarter, Jim, *Pan's Clan*, Sydney, Deaton and Spencer, 1932.

McGregor, Craig, *The Australian People,* Sydney, Hodder and Stoughton, 1981.

Mackaness, George and Joan S. (eds), *The Wide Brown Land: Selections from the Australian Poets*, rev. edn, Sydney, Angus and Robertson, 1949.

Macquarie Dictionary, see Delbridge

Maitland, Derek, *Breaking Out*, London, Allen Lane, 1979.

Marshall, Alan, *These Are My People*, Melbourne, F. W. Cheshire, 1944.

—— *I Can Jump Puddles*, Melbourne, F. W. Chesire, 1955.

—— *This Is the Grass*, Melbourne, F. W. Cheshire, 1962.

Martin, David, *The Hero of Too*, Melbourne, Cassell, 1965.

Melville, Kirsty (ed.), *The Australian Country Diary 1990, 1991, 1992, 1994*, Sydney, Simon and Schuster, 1989, 1990, 1991, 1993.

Meredith, John, *Duke of the Outback*, Melbourne, Red Rooster Press, 1983.

Mullally, John and Irene P. Sexton, *Libra and the Leprechaun*, Perth, M.A.S. Print, 1978.

Murray-Smith, Stephen (ed.), *The Dictionary of Australian Quotations*, Melbourne, Heinemann, 1984.

Newland, S., *Paving the Way*, London, 1893.

Newton, Dobe, *The Second Bushwackers Australian Song Book*, Melbourne, Anne O'Donovan, 1983.

Nicholson, J. H., *The Opal Fever*, Brisbane, 1878.

Ogilvie, William H., *Fair Girls and Gray Horses*, Sydney, Bulletin Newspaper Co., 1898.

O'Grady, John, *Gone Troppo*, Sydney, Ure Smith, 1968.

Old Bulletin Book of Verse, Melbourne, Lansdowne Press, 1975 [Sydney, Bulletin Newspaper Co., 1901].

Opie, Dora and Peter (eds), *The Oxford Book of Children's Verse*, London, Oxford University Press, 1973.

O'Reilly, M. J., *Bowyangs and Boomerangs*, Hobart, Oldham Beddome, and Meredith, 1944.

Ottley, Reginald, *By the Sandhills of Yamboorah*, London, Andre Deutsch, 1965.

—— *The Roan Colt of Yamboorah*, London, Andre Deutsch, 1966.

—— *Rain Comes to Yamboorah*, London, Andre Deutsch, 1967.

—— *Brumbie Dust*, New York, Harcourt, Brace and World, 1969.

—— *Jim Grey of Moonbah*, London, Collins Clear-Type Press, 1970.

Pilbeam, Brian, *The First Hundred Years—J. Furphy and Sons: Looking Back, 1873–1973*, Shepparton, Vic., J. Furphy and Sons, 1973.

Porteous, R. S., *Cattleman*, Sydney, Readers Book Club, 1962.

Potted Wisdom and Happy Thoughts, roneoed pamphlet stamped '4th Div. A.M.C. Assn.' (presumably Army Medical Corps), nd.

Ransom, A. S. (ed.), *The Australian National Dictionary: A Dictionary of Australianisms on Historical Principles*, Melbourne, Oxford University Press, 1988.

Roderick, Colin (ed.), *Henry Lawson: Collected Verse*, 3 vols, Sydney, Angus and Robertson, 1967–69.

—— *Henry Lawson: Short Stories and Sketches, 1888–1922*, 4 vols: Vol. 1, *Henry Lawson: Collected Prose*, Sydney, Angus and Robertson, 1972.

Ronan, Tom, *Once There Was a Bagman*, Melbourne, Cassell, 1966.

—— *Vision Splendid*, Melbourne, Lloyd O'Neil, 1972.

Ross, Alan, *Australia '63*, London, Eyre and Spottiswoode, 1963.

Rudd, Steele, *On Our Selection and Our New Selection*, Sydney, Lloyd O'Neil, 1973.

Schodde, R. and Sonia Tidemann (eds), *Reader's Digest Complete Book of Australian Birds*, 2nd edn, Sydney, NSW Reader's Digest Services, 1986.

Searcy, Alfred, *By Flood and Field*, Melbourne, George Robertson and Co, 1911.

Sidney, J., *A Voice from the Far Interior of Australia*, London, 1847.

Simpson, John (ed.), *Concise Oxford Dictionary of Proverbs*, Oxford, Oxford University Press, 1985.

Smith, Keith, *OGF*, Sydney, Ure Smith, 1965.

Stewart, Douglas and Nancy Keesing (eds), *Australian Bush Ballads*, Sydney, Angus and Robertson, 1955.

—— *Old Bush Songs and Rhymes of Colonial Times*, Sydney, Angus and Robertson (Australian Classics), 1976.

Stow, Randolph, *The Singing Bones*, Sydney, Angus and Robertson, 1969.

Stuart, Donald, *Wedgetail View*, Melbourne, Georgian House, 1978.

Thatcher, C. R., *Colonial Songster*, rev. edn, Melbourne, Charlwood, 1865.

Thatcher, R., *Something to His Advantage*, Sydney, 1875.

Tritton, H. P., *Time Means Tucker*, Sydney, Bulletin Newspaper Co., 1959.

Trollope, A., *Australia and New Zealand*, Vol. 1, London, 1873.

Underwood, Douglas, *Crocodiles and Other People*, Adelaide, Rigby, 1963.

Upfield, Arthur, *Bony and the Mouse*, London, Heinemann, 1959.

—— *The Lure of the Bush*, New York, Doubleday / Crime Club, 1965.

Walsh, Gerald, *Pioneer Days: Innovations in Australia's Rural Past*, Sydney, Allen & Unwin, 1993.

Wannan, Bill, *The Australian: Yarns, Ballads, Legends, Traditions*, Adelaide, Rigby, 1954.

—— *Australian Folklore: A Dictionary of Lore, Legends and Popular Allusions*, Melbourne, Lansdowne Press, 1970.

Wannan, Bill (ed.), *Modern Australian Humour*, Melbourne, Landsdowne Press, 1962.

—— *Fair Go, Spinner*, Melbourne, Lansdowne Press, 1964.

—— *My Kind of Country: Yarns, Ballads, Legends, Traditions*, Adelaide, Rigby, 1967.

—— *Bill Wannan's Folklore of the Australian Pub*, Melbourne, Macmillan, 1972.

—— *Dictionary of Australian Humorous Quotations and Anecdotes*, Melbourne/Sydney, Macmillan, 1974.

White, J. C., *Queensland the Progressive*, London, 1870.

Wilkes, G. A., *A Dictionary of Australian Colloquialisms*, Sydney, Sydney University Press, 1990.

Willey, Keith, *Tales of the Big Country*, Adelaide, Rigby, 1972.

—— *You Might as Well Laugh, Mate: Australian Humour in Hard Times*, Melbourne, Macmillan, 1984.

Wood, Thomas, *Cobbers*, London, Oxford University Press, 1936.